Signs and Symbols of Japan

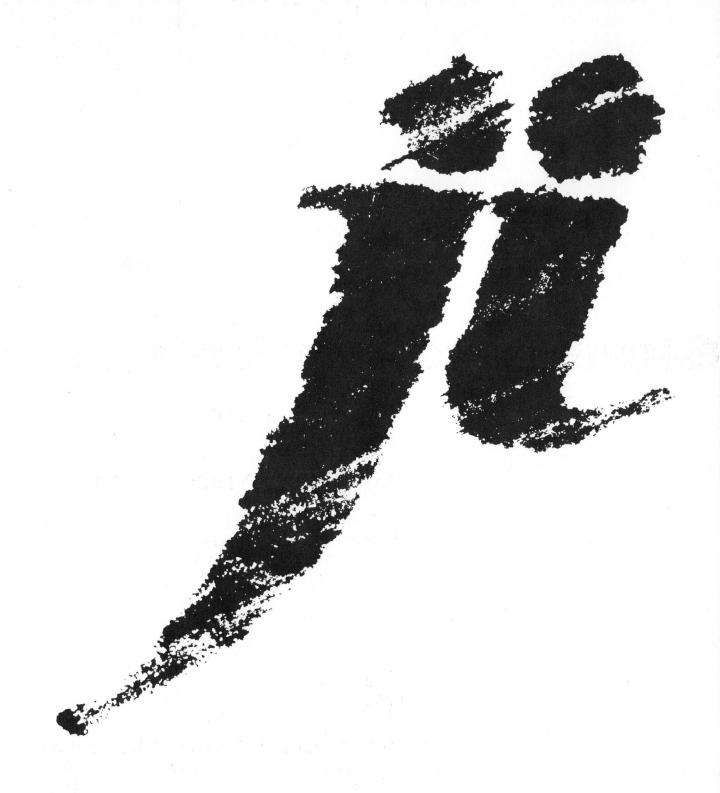

Signs and Symbols of Japan

Mana Maeda

PHOTOGRAPHS BY
Kiyokatsu Matsumoto

INTRODUCTION BY
Donald Richie

KODANSHA INTERNATIONAL LTD.,
TOKYO, NEW YORK AND SAN FRANCISCO

Distributors:
United States: *Harper & Row, Publishers, Inc., 10 East 53rd Street, New York, New York 10022.* South America: *Harper & Row, International Department.* Canada: *Fitzhenry & Whiteside Limited, 150 Lesmill Road, Don Mills, Ontario.* Mexico and Central America: *HARLA S. A. de C. V., Apartado 30–546, Mexico 4, D. F.* United Kingdom: *TABS, 7 Maiden Lane, London WC 2.* Europe: *Boxerbooks Inc., Limmatstrasse 111, 8031 Zurich.* Australia and New Zealand: *Book Wise (Australia) Pty. Ltd., 104–8 Sussex Street, Sydney 2000.* Thailand: *Central Department Store Ltd., 306 Silom Road, Bangkok.* Hong Kong and Singapore: *Books for Asia Ltd., 30 Tat Chee Avenue, Kowloon; 65 Crescent Road, Singapore 15.* The Far East: *Japan Publications Trading Company, P. O. Box 5030, Tokyo International, Tokyo.*

Published by Kodansha International Ltd., 2–12–21 Otowa, Bunkyo-ku, Tokyo 112 and Kodansha International/USA Ltd., 10 East 53rd Street, New York, New York 10022 and 44 Montgomery Street, San Francisco, California 94104. Copyright in Japan 1975 by Kodansha International Ltd. All rights reserved. Printed in Japan.

LCC 74–29569
ISBN 0–87011–247–3
JBC 1070–874869–2361

First edition, 1975.

CONTENTS

Introduction

The traveler to Japan soon notices a vast number of signs and symbols around him. These marks, figures, emblems, purveying information and displaying advertisements, crowd the cities and dominate the horizons. Signs seem to be everywhere—on roofs, walls, doors, and windows. Almost every available surface carries a message.

This message the traveler has little hope of deciphering. If he could read them, he would probably pay them no more attention than he gives the plethora of signs and symbols in his own country. Since, however, he cannot read them, his attention is drawn to them all the more strongly.

They are obviously a functional part of the environment. They clearly proclaim. And they are often beautiful. The visitor admires the pleasing abstract shapes, the skill with which many are executed. His enjoyment of them is both primary and proper because by tradition signs and symbols in Japan are meant to be aesthetically pleasing. Yet the illiterate visitor is missing a great deal.

To be sure, some signs are universal. Red is for negative directions, green for permissive, yellow for warning. This he understands, as well as the use of red to signify hot, and blue to show cold. Moreover, since Japan uses universal pictographs, he can tell which is the men's toilet or when he is approaching a railroad crossing. Most other messages, however, remain opaque, though to the Japanese around him the meaning is so transparent that they seem not even to notice.

If the visitor stays for a time he will begin to discriminate among the messages. Just as a child learns, he will start by sorting the signs into groups or classes, and the first class will probably be according to shape. Traffic signs, for example, are usually distinguished not only by a written message but also by shape. In America their form is standardized: stop signs are octagonal; yield signs are equilateral triangles with one point down; warning signs are diamond-shaped. Japan has an analogous shape vocabulary that one readily learns.

The next method of sorting the signs out is by location. In most countries, municipal information—"Don't walk," "Keep to the left"—is posted in a predetermined and logical place. Traditionally *all* information is this rigorously placed in Japan. Thus the Japanese restaurant has three positions where its name and sometimes its speciality are displayed—the signboard, the shop curtain and the lantern. Once in Japan, the foreigner soon learns to look in these places, but even then he often does not know what he is seeing. The reason is the language, the medium by which the message is conveyed.

The Japanese written language is a complex of ideograms and syllable signs

covered broadly by the term *ji*, which means "letters." It is comprised of Chinese characters called *kanji*, and two syllabaries. The first syllabary, *hiragana*, is used for phonetic renderings of native Japanese words and the second, *katakana*, is usually for phonetic renderings of words transliterated from other languages.

A Chinese character usually represents a whole idea, and thus it is a complete word in itself, a system that reduces the need for sentence structure. In a country depending on an alphabet, a sentence, even if elliptical, is needed to convey a thought of any complexity. In *kanji* country it is the character itself that often stands for all, and is all that is necessary. Centuries of using this system have developed in people an extraordinary ability not only to read the characters themselves but also the nuances and overtones that surround and color each character.

We follow a somewhat similar process when, for example, we read "The Pause that Refreshes," and absorb its message without even thinking what the phrase means. It could be argued, however, that when the Japanese read the character 酒 (the *kanji* for sake, rice liquor), associations of conviviality, warmth, solace and enjoyment emerge more strongly than when we read the word "whisky." Our word is a combination of alphabetic letters, like every other word we have, while the Chinese character stands more strongly for the thing itself. It represents it more directly than a word written with alphabetic letters can, and this helps account for the way the Japanese react to their signs. (Whether or not such an argument is valid, at least the Japanese themselves seem convinced of it.)

Just as the Japanese are alive to the nuances of the word itself, they are also aware of the way the word is written. In the West, unless you work in publishing or printing, you are no longer likely to be sensitive to the effects of different styles of typography. We know the bold lettering of news headlines and the fanciful script of wedding invitations, but few others, and the fact that virtually all our communications are printed mechanically has blinded us to the infinitely subtler nuances of handwriting styles. In Japan, however, calligraphy is still an important aspect of life.

The effectiveness of any sign or symbol depends on the nexus of associations surrounding it. A symbol reminds us of all the attributes we associate with what it represents. Even the simplest of symbols—NO ENTRY or ⊖ — can carry fairly complicated associations, and much more is conveyed when the writing itself gives a resonance to the basic sense.

Again we can find an example in our own culture. If in America we come across 𝔜𝔢 𝔒𝔩𝔡𝔢 𝔈𝔫𝔤𝔩𝔦𝔰𝔥 𝔗𝔢𝔞𝔯𝔬𝔬𝔪𝔢, we know more than that food and drink

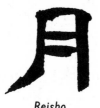

Reisho

月

Kaisho

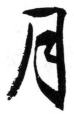

Gyosho

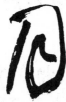

Sosho

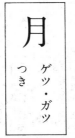

月

ゲ
ッ
・
ガ
ッ

つ
き

Printed form with
hiragana (left) and
katakana (right).

are available. The message is grasped at once, for the lettering gives an indication of what kind of food and drink and what kind of ambience to expect. Both the affectations of Gothic script and of carefully obsolete spelling indicate gentility and respect for age. Certainly the atmosphere will be more contrived than in an establishment that simply proclaims EATS. There is also the implication that the clientele of such a tearoom will be older rather than younger, with more women than men. All these complicated overtones we take in at a glance. The full message is understood without our thinking about it. We receive the message the proprietors have directed at us. We have an instant index of the place.

In Japan the process is essentially similar. The reading and interpretation, however, allow for far more complicated judgments. The main reason for this is that there are many styles of script, each with its own associations.

To begin with, the Japanese distinguish among four major categories of written scripts. The first of these, *reisho*, evolved from China before the Han dynasty, and was originally the lettering used for inscriptions carved on stone or on seals. The second, dating from late Han, is called *kaisho*. It was a calligraphic style from which the Japanese developed *katakana*. The third is *gyosho*, the style in which most Japanese write. The fourth style is the fluid *sosho*, from which came *hiragana*, or, as it was once called, *hentaigana*. It is so loose that it is often difficult to read and the Japanese say that anything more fluid than *sosho* is illegible. These styles will become clearer after examining the illustrations in the margin. The character is *tsuki*, or "moon," and this pronunciation is indicated phonetically in the *hiragana* under the printed (as opposed to drawn) example at the bottom left. The two pairs of *katakana* below it (separated vertically by a dot) indicate two other pronunciations (and meanings) also carried by this character. First is *getsu*, as in *getsuyobi*, the word for "Monday."(We have something similar. We have "moon" and we also have a form of the word in Monday.) The second group of *katakana* indicates another meaning and pronunciation: *gatsu*, the suffix used in the months—*ichigatsu*, *nigatsu*, *sangatsu* (January, February, March), etc. This, then, is what the character means.

The various scripts, however, indicate or create nuances. To explain this, let us pretend that there are four restaurants, each calling itself *Tsuki* and using this character. What kind of atmosphere would you expect if each one used a different style of lettering?

To Japanese, the *reisho* character could only indicate a Chinese restaurant or else a place with very old associations, either authentic or assumed. The feeling might be a little like our Olde Tearoome, China being to Japan as

England is to America. The second place, with its name in *kaisho* script would not tell too much since this is the style widely used for many signs. The nuances might be understood as "traditional" or as "everyday." In either case there would be an association with Tokyo and the culture implied by the "new" capital.

With signs in *gyosho* or *sosho*, however, one's thoughts would turn to the old capital, Kyoto, and its softer, mellower moods. A shop sign in *sosho* indicates a degree of refinement, a kind of delicacy that could be feminine. *Sosho*, which many Japanese find hard to read, can also indicate self-conscious elegance—perhaps something with an artistic flavor.

While all of this may seem recondite enough to the Westerner, it is only the beginning. Each of these styles has subdivisions. There is, for example, the script called *Edo-moji*. This category, associated with Tokyo during the eighteenth century, consists of styles named *kantei*, *yosei*, *joruri*, *kago*, and *kaku-moji*. From each of these come other styles. *Kantei*, for example, produced the *kabuki-moji*, a style associated mainly with that drama, and the *sumo* or *chikara-moji*, connected mainly with *sumo* wrestling. In addition, there is the popular Edo style called *hige* (or "whiskered")-*moji*, in which individual bristle strokes are visible. A cursive script, near *gyosho* in feeling, the "whiskered" *moji* (see plates 66–72), though intended to be spontaneous and free, is, in fact, rigidly stylized. The passage of the brush must leave seven distinct bristle marks, in the narrower parts of the character it must show five, and as it leaves the paper it must show three. This seven-five-three formula, derived from China, is an auspicious combination applied to many occasions, such as the shrine visits of young children at these three ages.

Again, all of this is arcane to Westerners—and, it might be added, is becoming remote to younger Japanese as well. Yet there is still a wealth of nuance, a treasury of shared and accepted associations that all Japanese derive from their signs and symbols.

The process is less complicated than it sounds, because no conscious thought is involved in this kind of reading. Such nuances are felt at once or not felt at all. Since associations are involved—"feelings" rather than "thoughts"—putting them into words makes them sound more rigid and definitive than they are.

Japan's proliferation of signs and symbols consists overwhelmingly of commercial advertising. Yet the viewing audience is not only the potential paying customer but also the neighbors, the interested, the uninterested, the whole society, and (if we consider votive tablets) the gods themselves. Advertising in Japan is a public art and a cultural force.

Underlying this art of advertising is the more basic art of calligraphy. Whether the medium is black ink or neon tubing, the aesthetics of calligraphy can move foreigners almost as deeply as Japanese. It is the beauty of the forms as much as their meaning that is appreciated. Among Japanese, an individual is still judged by the way he forms his characters. Letters from strangers are judged not only for what they say but also for the way they are written. Bad writing still means a bad, or at least weak, personality. Since the Japanese typewriter remains at best a cumbersome affair and is, at any rate, never used for personal correspondence, a good, clean, even elegant hand is a requisite. Aesthetic qualifications become moral qualifications in Japan. Beauty becomes honesty.

Japanese letters, or *ji*, are both signs and symbols. Alfred North Whitehead has made a distinction between "pure instinctive action, reflex action, and symbolically conditioned action," and thus recognized three kinds of responses to the messages—signals, signs, and symbols. Ernest Cassirer has said, further, that "symbols—in the proper sense of the term—cannot be reduced to mere signs. Signals and symbols belong to two different universes of discourse: a signal is part of the physical world of being, a symbol is part of the human world of meaning. Signals are operators, symbols are designators."

It is plain then that *ji* are concerned both with reflex action and with symbolically conditioned action. Some further distinction between signs and symbols is necessary, however. One might say that signs are messages occurring so regularly that we respond without thought. Pavlov's dog was responding to a sign.

With symbols we leave the other animals, for only man responds to them. They were invented for the purpose of communication with others and with himself. Lawrence Frank has said that a symbol "becomes meaningful and evokes human responses when, and only when, a perceiver of that symbol projects meaning into it and responds to it in terms of the meaning which he has learned as appropriate for that symbol." A symbol must therefore be "group-recognized and commonly used," either through tradition or else everyone's agreeing upon it. In any event knowledge and acceptance of the meaning is necessary for it to be effective.

This book then is mainly made up of *ji* which are, by their nature, symbols. At the same time, *ji* can and do act also as signs. It is in this sense that these words are used in this book.

DONALD RICHIE

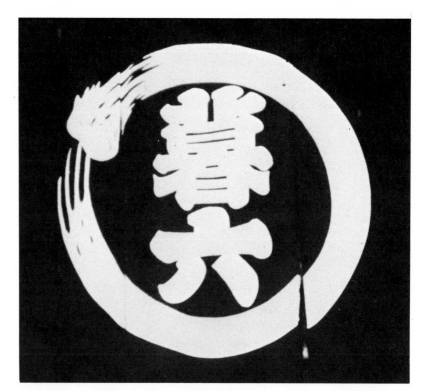

1 KAMBAN NOREN CHOCHIN

The signboard (*kamban*), the curtain (*noren*) and the lantern (*chochin*) —these are the three customary places where a shop name appears, and sometimes they may also show what is offered by the shop. Besides these direct communications, they indicate through a variety of subtle effects the atmosphere within and the image the shop has of itself.

These effects are achieved through the choice of which system of Japanese letters is used to convey the message—and even of which style they are written in—as well as by the combinations of color used and how the composition is viewed as a whole. To Western eyes it is a somewhat arcane vocabulary, for each calligraphic style, with its many variations, has its own historical and aesthetic associations that are read by the Japanese as easily as the literal message.

Despite the frequent catastrophes that have devastated Japan over the last half-century, surprisingly many old signs survive, scattered here and there throughout the country. The most traditional examples are to be found in the most traditional areas. Of these the primary—and most obvious—area is Kyoto. The mere mention of the name brings to the Japanese mind colors and textures that are unique and remind them of a sense of style partly architectural, partly atmospheric, that is its essence. There the genteel tradition of paying fastidious attention to the smallest of details has resulted in signs that are epitomes of sensitivity and eloquence of design.

Another area is Takayama, in Gifu Prefecture. This is an old town, the center of many of the region's arts and crafts. Wars and cataclysms seem to have bypassed the town, so many of the buildings remain in their original condition, and their *noren* and *kamban*, even when new, reflect the simplicity and vigor of folk art itself.

Yet a third area is Aizu-Wakamatsu, in Fukushima Prefecture. This was once the seat of a feudal lord and therefore it had strong ties with the old capital city of Edo (now Tokyo). It is here rather than in Tokyo that one finds the typical styles of Edo calligraphy—rounded, bold, rhythmical, and dynamic. These styles are imbued with the Genroku era, when the great printmakers, actors and courtesans flourished.

Tokyo itself, in spite of the great metropolitan mess it has become, still has many quiet corners (mainly in the Asakusa and Ueno districts), where tradition flourishes and where the *kamban* and *noren* are evidence of this. In other sections new and old have been more or less successfully blended. In glittering Ginza, for example, the calligraphy of the past is wrought in the neon of the present.

Wherever signs are displayed, it is firmly believed by the Japanese that the more appealing the *noren* or *kamban*, the better the shop and the quality of its goods. In this sense the signs are symbolic in a very direct way.

12

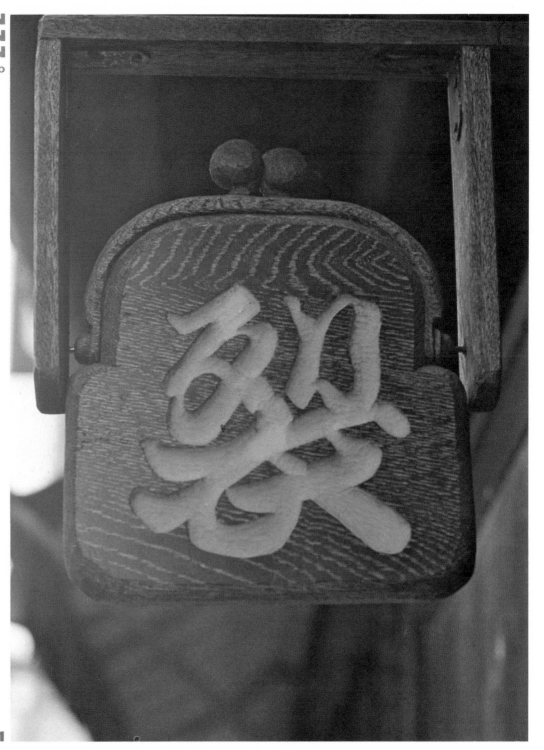

1

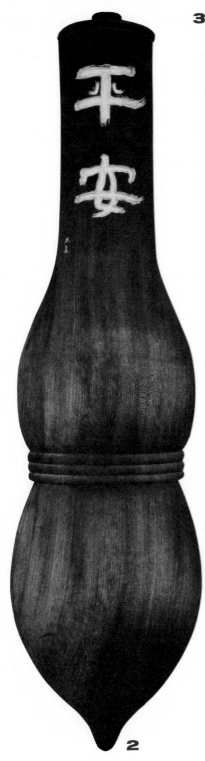

2

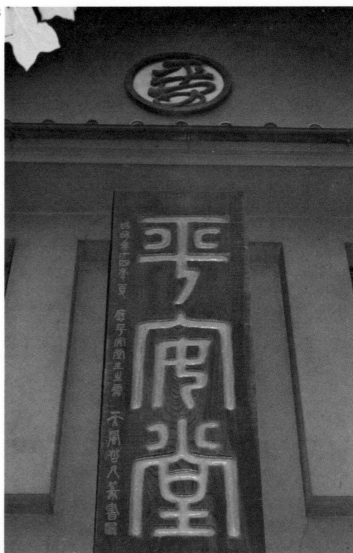

3

KAMBAN · NOREN · CHOCHIN
Tokyo

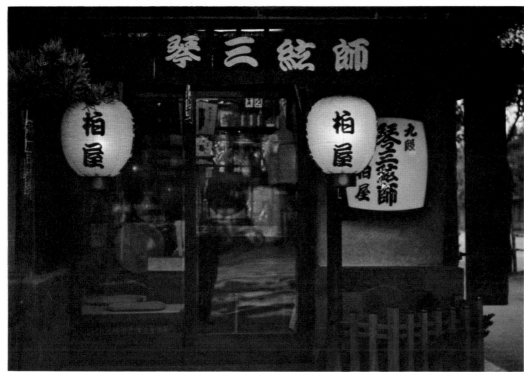

KAMBAN·NOREN·CHOCHIN
Tokyo

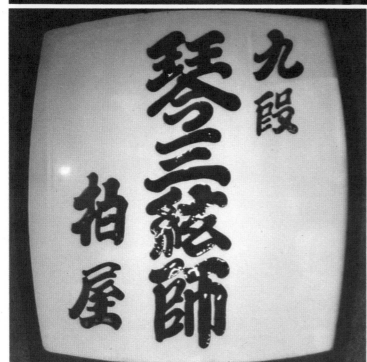
5

**KAMBAN
NOREN
CHOCHIN**
Kyoto

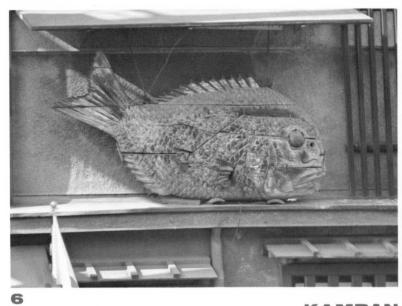

6

**KAMBAN
NOREN
CHOCHIN**
Kyoto

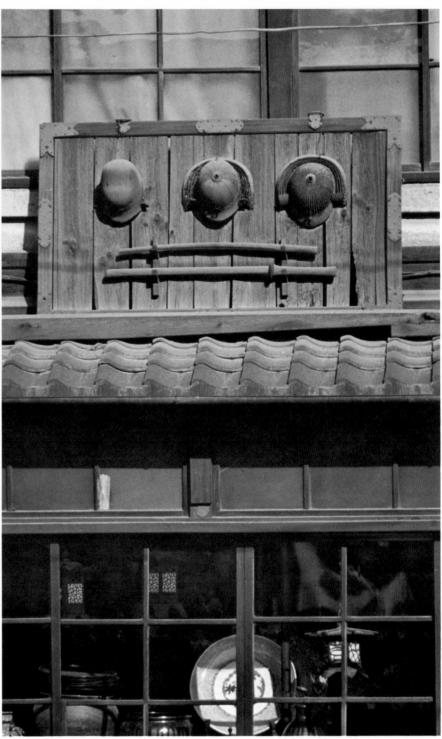

7

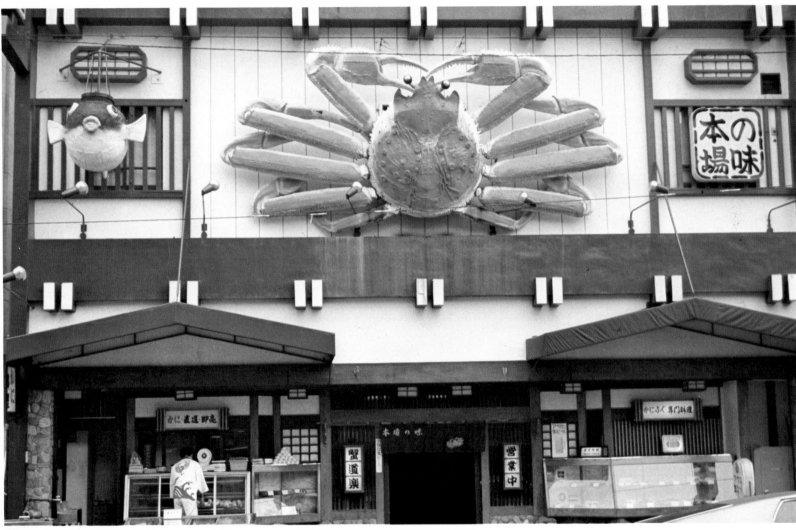

KAMBAN
NOREN
CHOCHIN
Aizu-Wakamatsu

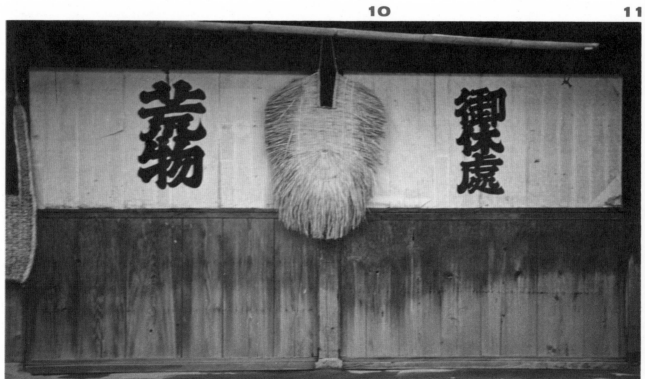

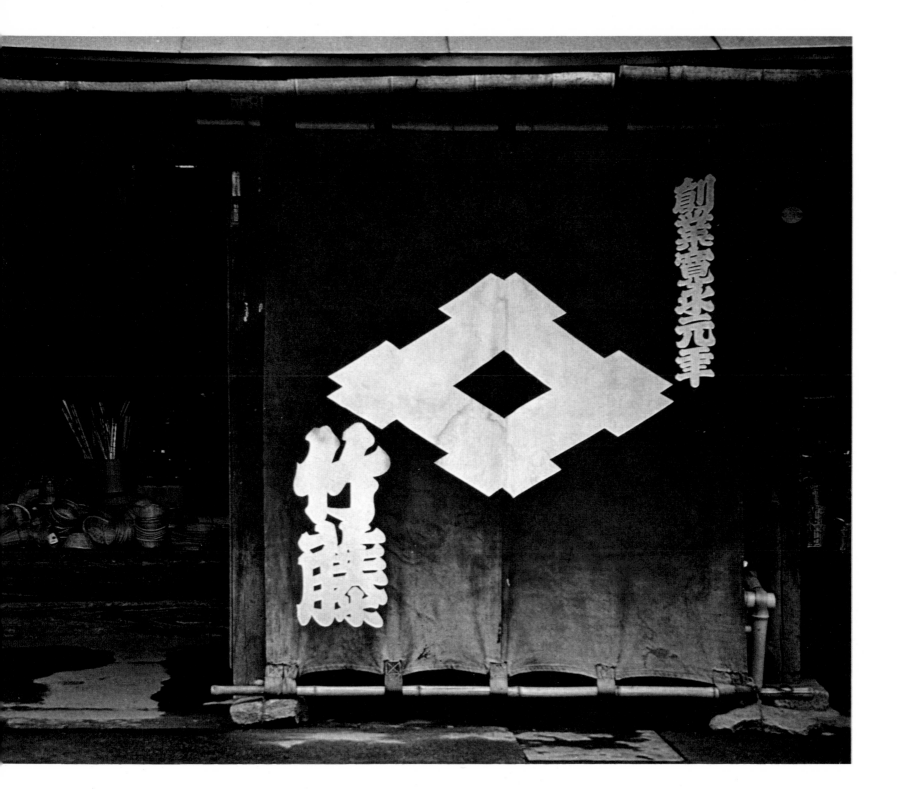

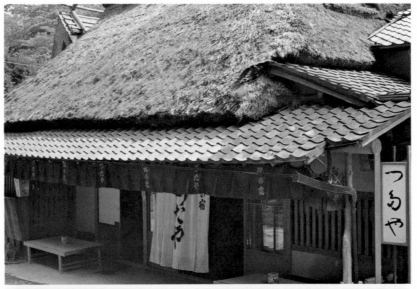

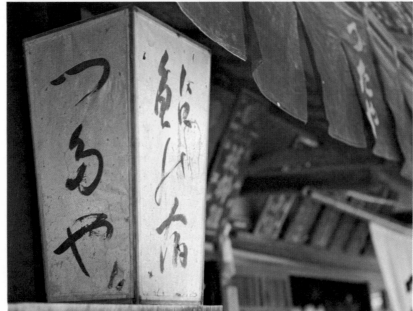

KAMBAN·NOREN·CHOCHIN
Okusaga

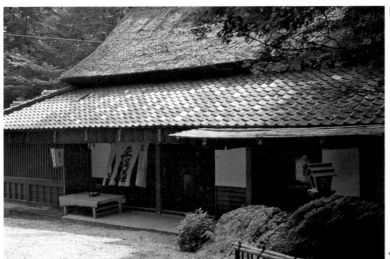

14

16

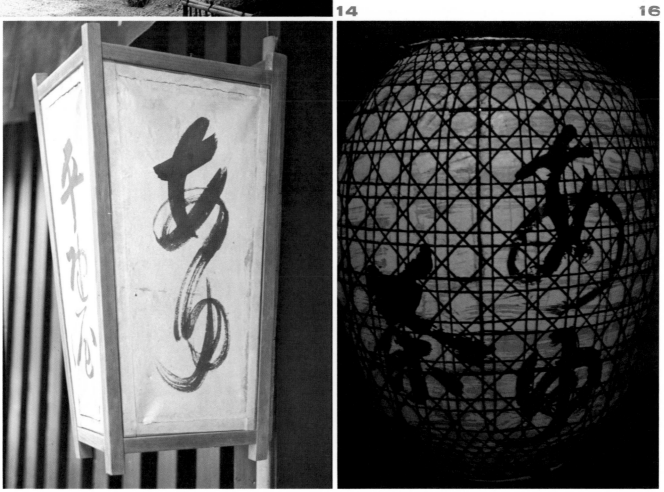

15

KAMBAN·NOREN·CHOCHIN
Aizu-Wakamatsu

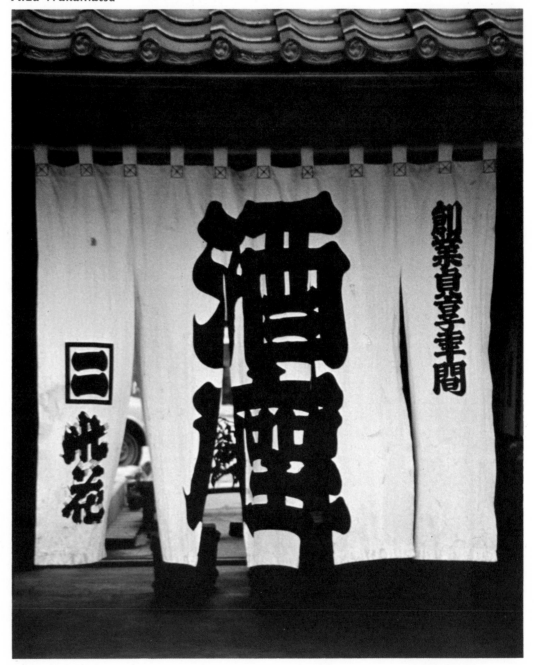

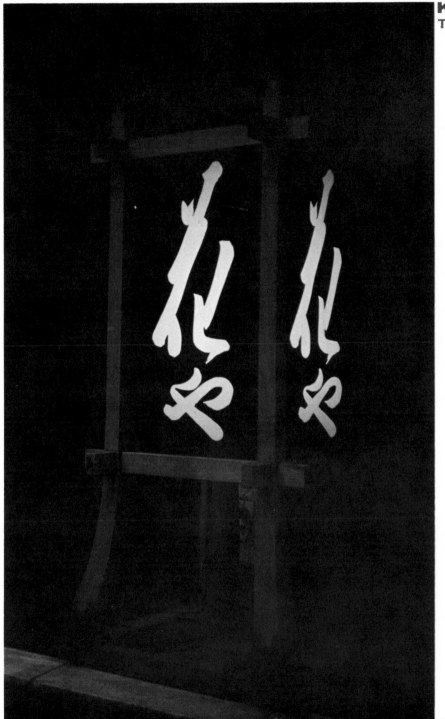

18

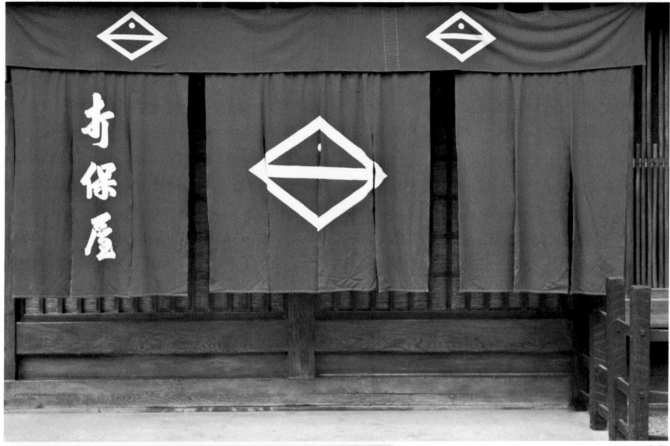

**KAMBAN
NOREN
CHOCHIN**
Hida-Takayama

19

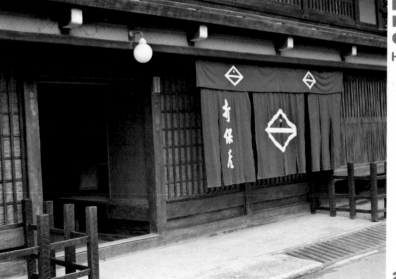

20

KAMBAN·NOREN·CHOCHIN
Tokyo

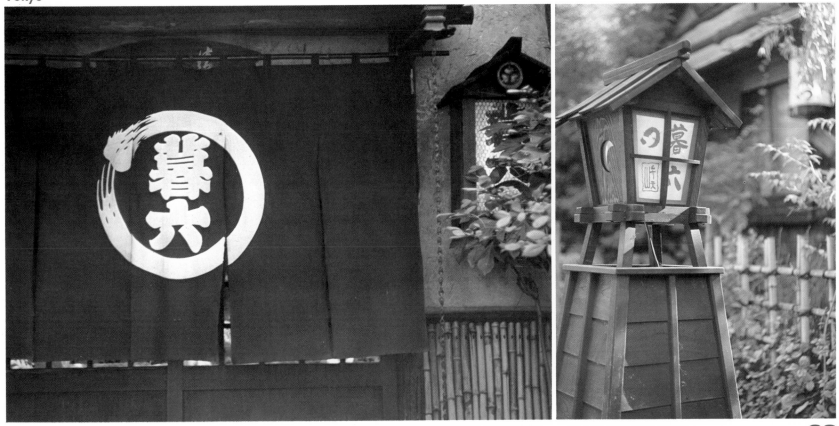

21 22

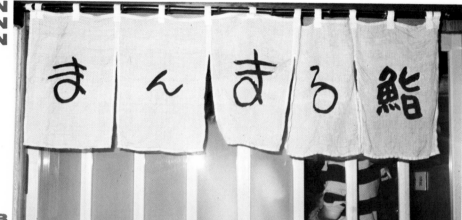

23

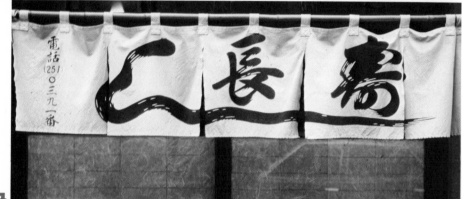

24

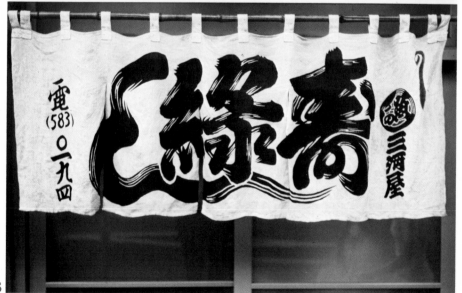

25

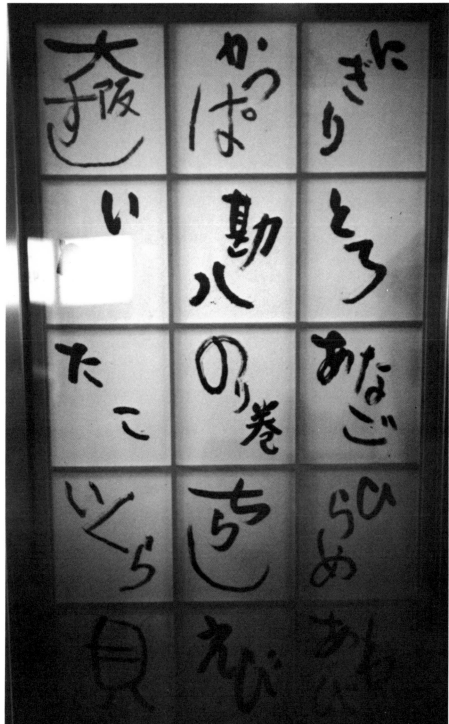

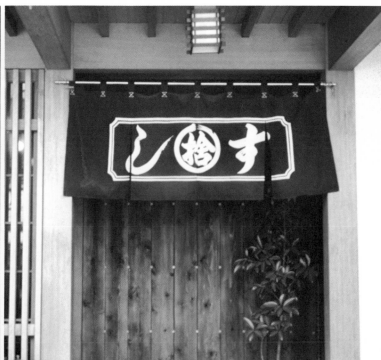

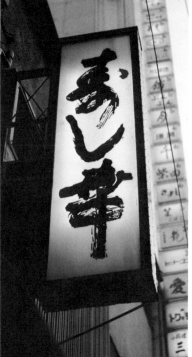

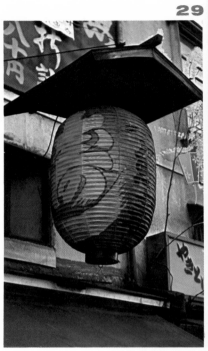

29

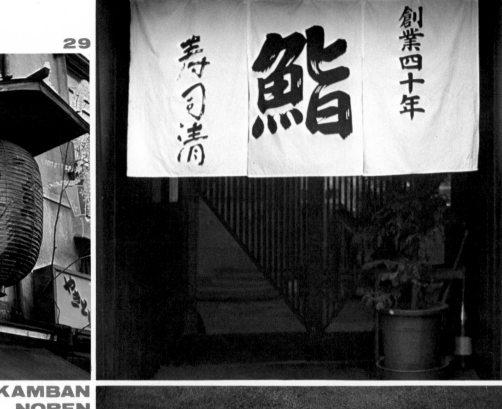

30

KAMBAN
NOREN
CHOCHIN

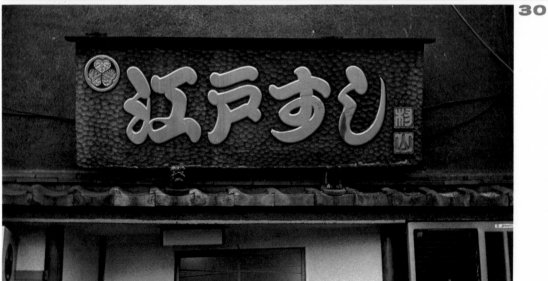

31

32

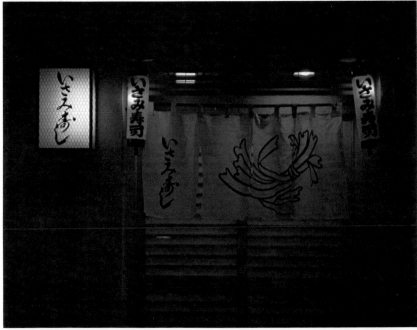

34

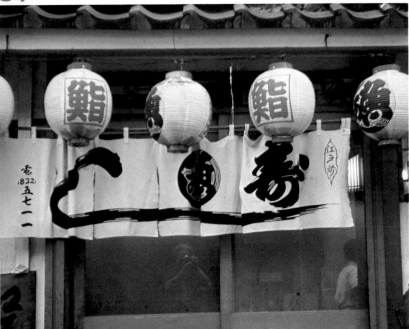

35

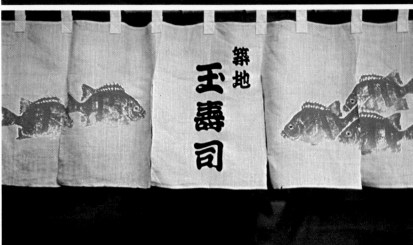

KAMBAN
NOREN
CHOCHIN

33

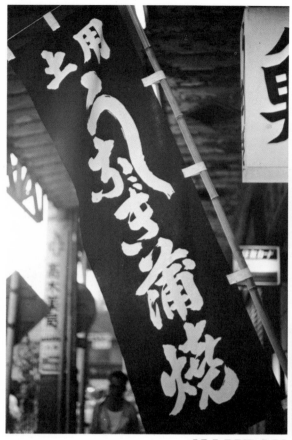

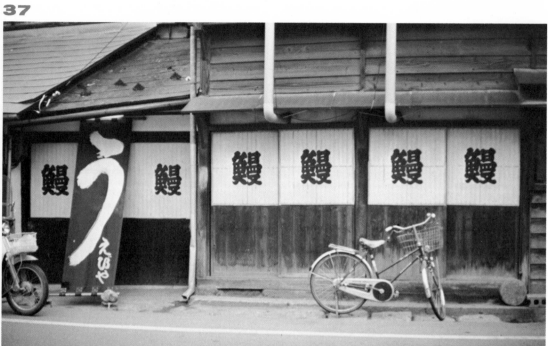

**KAMBAN
NOREN
CHOCHIN**

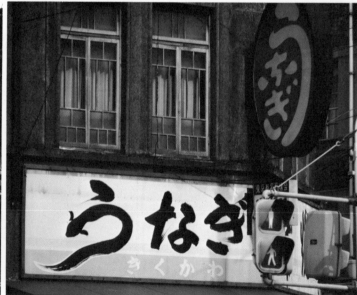

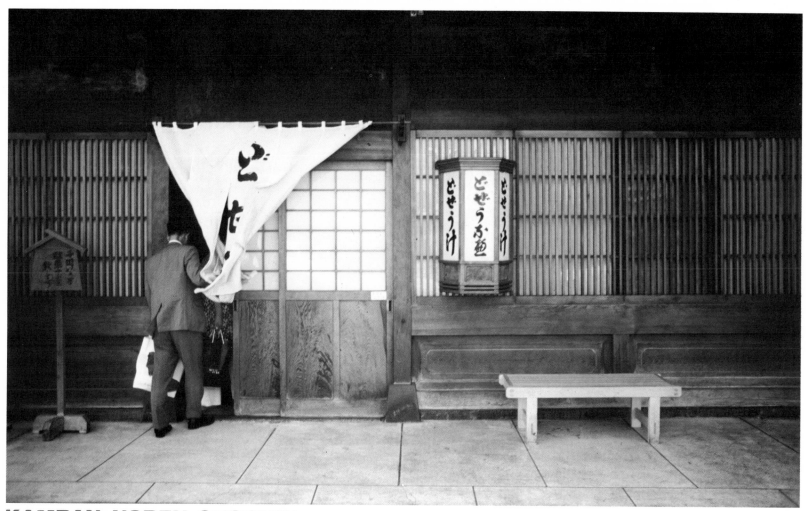

KAMBAN·NOREN·CHOCHIN
Tokyo

40

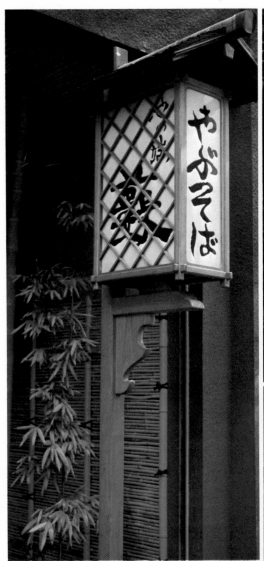

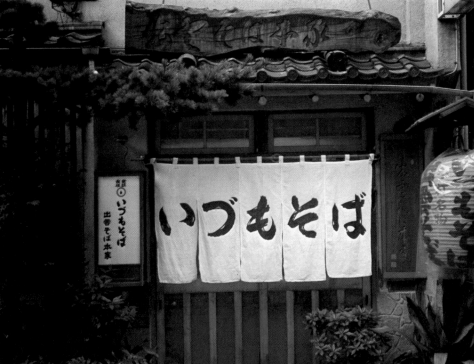

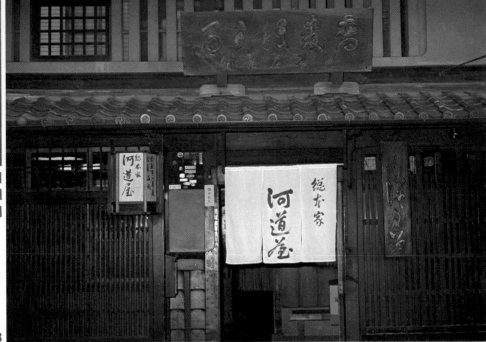

41 · 42　　KAMBAN
　　　　　　　NOREN
　　　　　　　CHOCHIN

43

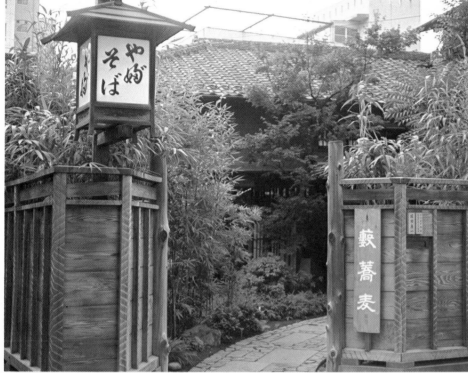

44

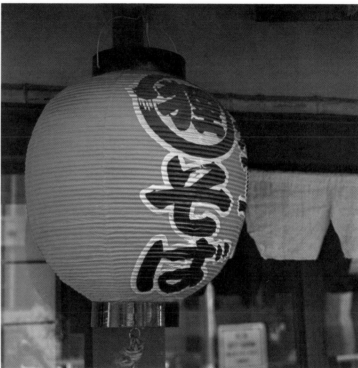

46

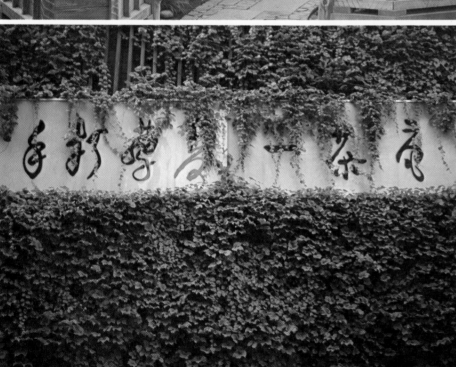

45

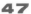

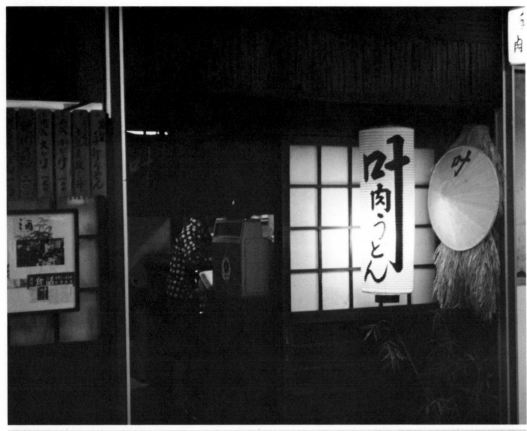

**KAMBAN
NOREN
CHOCHIN**

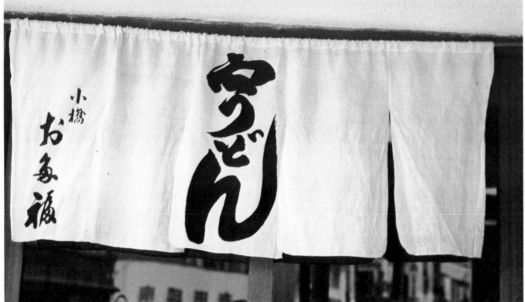

KAMBAN·NOREN·CHOCHIN
Hida-Takayama

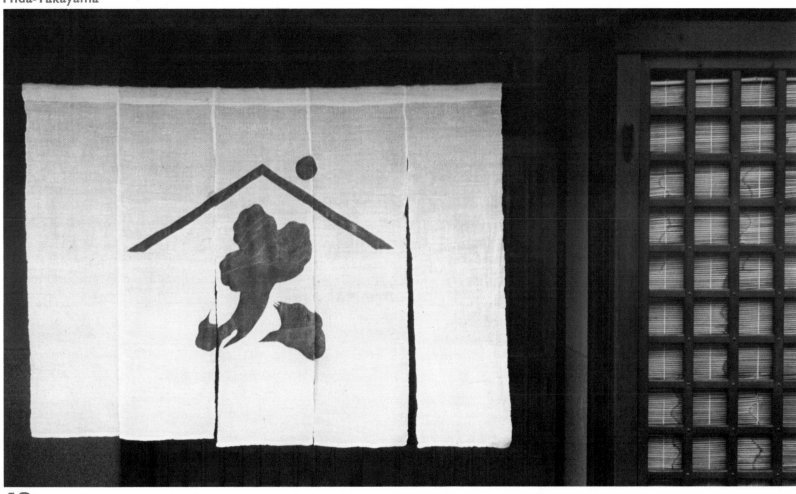

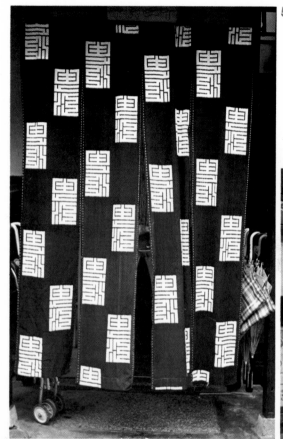

50

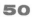

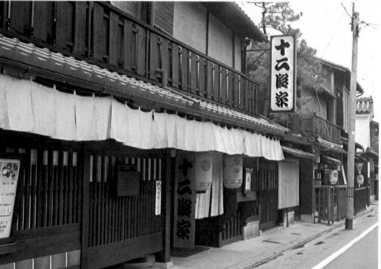

52

KAMBAN
NOREN
CHOCHIN
Kyoto

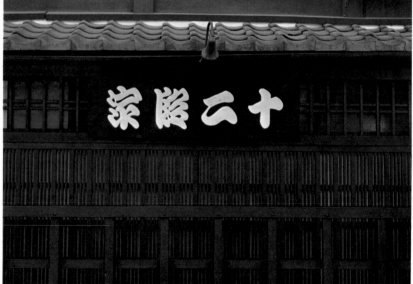

51

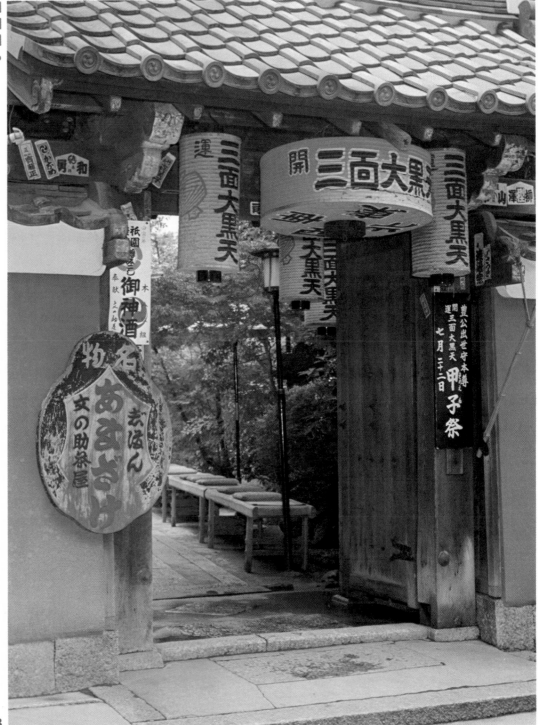

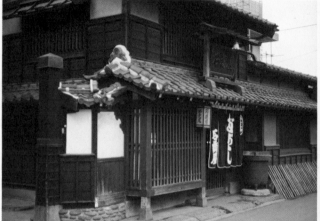

54

**KAMBAN
NOREN
CHOCHIN**
Sendai

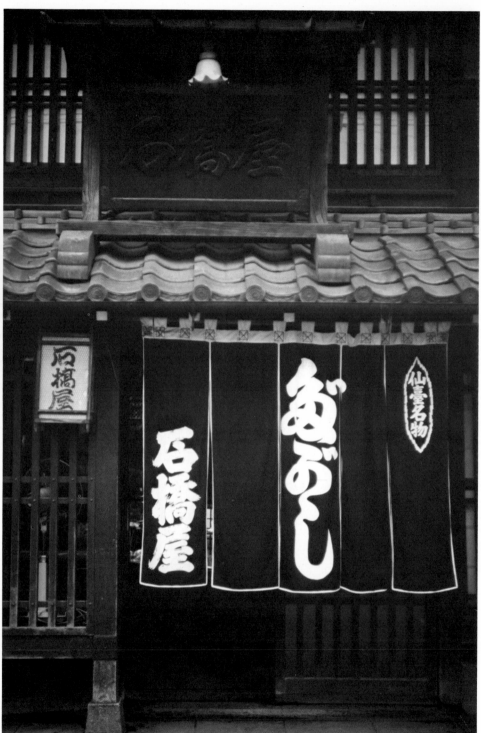

55

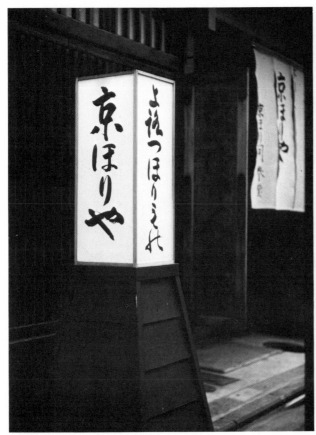

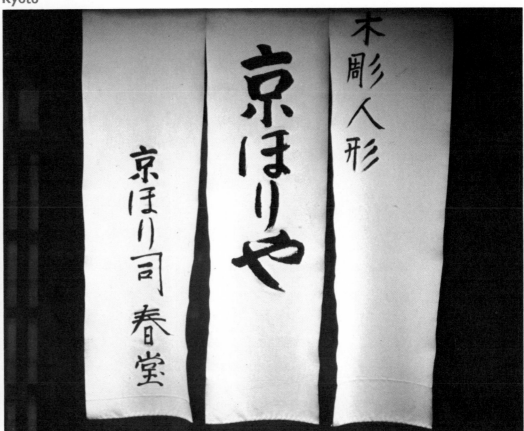

56 57

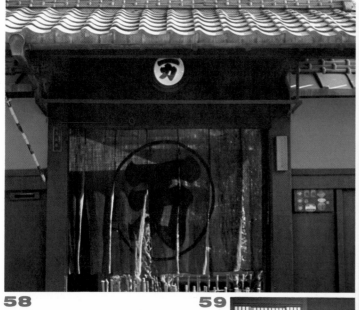

58

59

KAMBAN·NOREN·CHOCHIN
Kyoto

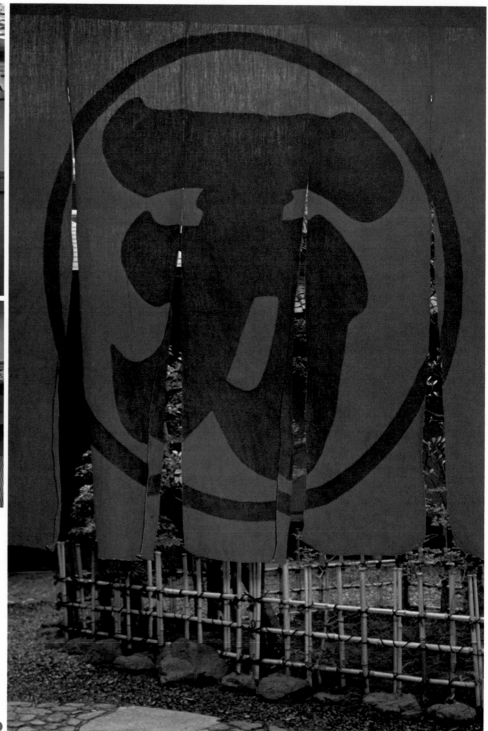

60

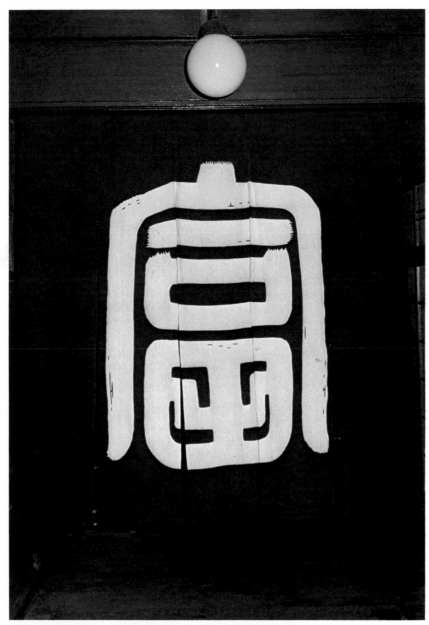

KAMBAN · NOREN · CHOCHIN
Kyoto

61

KAMBAN·NOREN·CHOCHIN
Kyoto

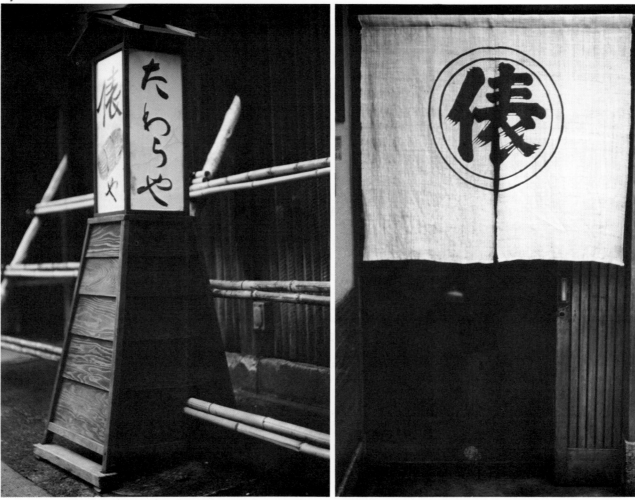

62 63

KAMBAN
NOREN
CHOCHIN
Kyoto

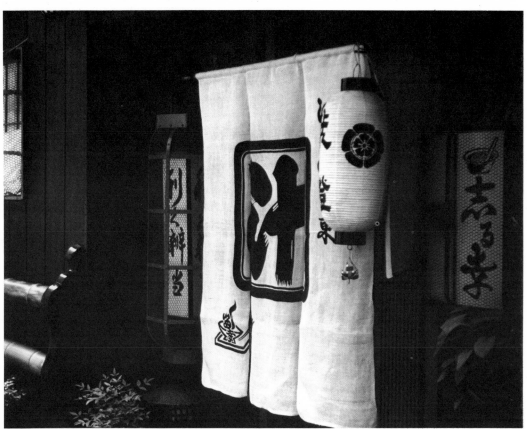

64

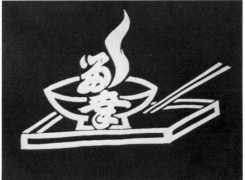

65

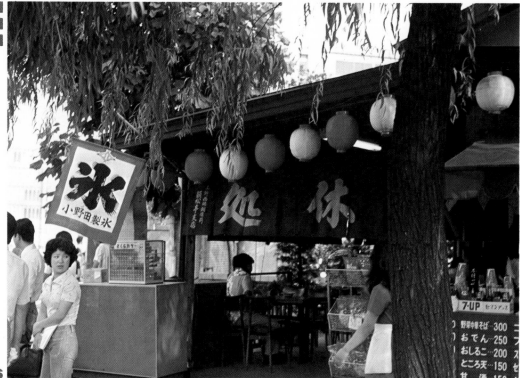

66

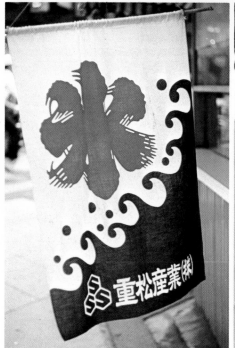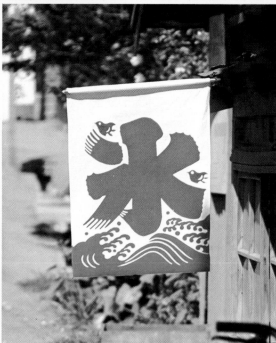

67 · 68

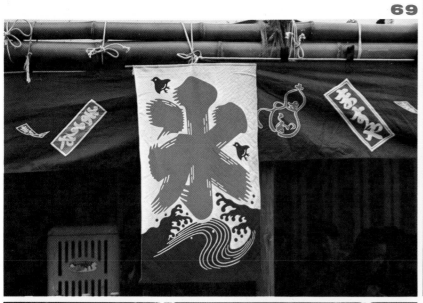

71

69

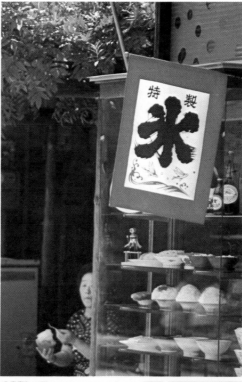

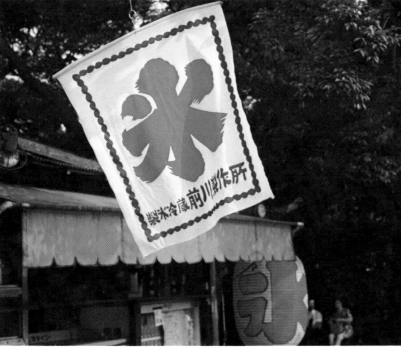

70

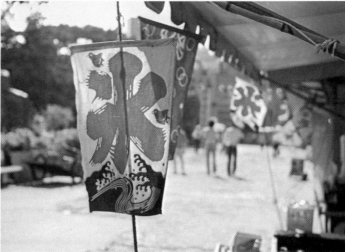

72

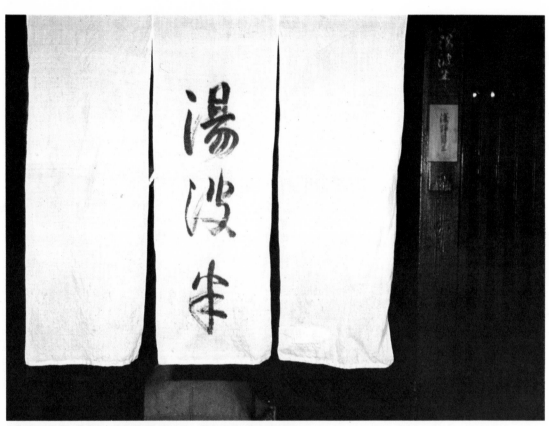

KAMBAN·NOREN·CHOCHIN
Kyoto

73

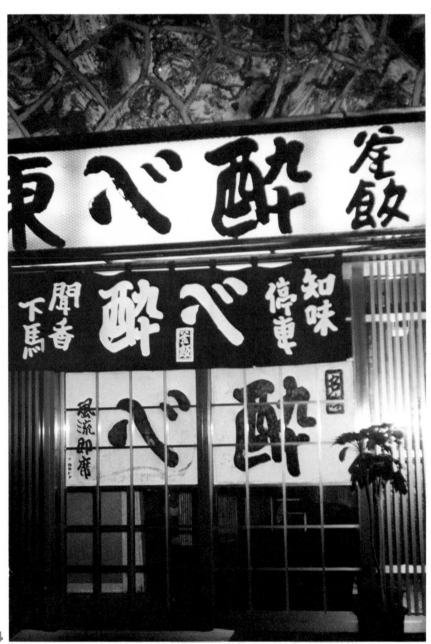

KAMBAN·NOREN·CHOCHIN
Osaka

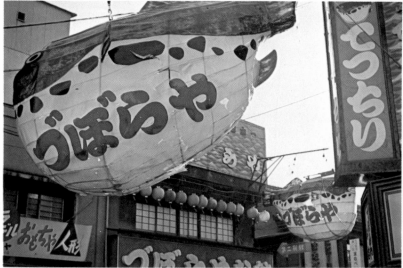

75

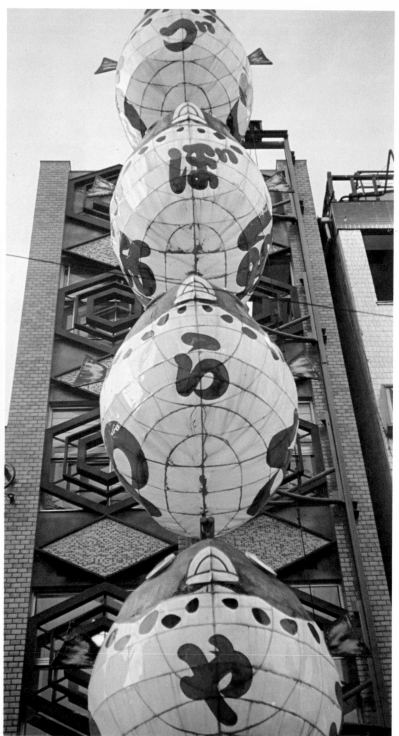

76

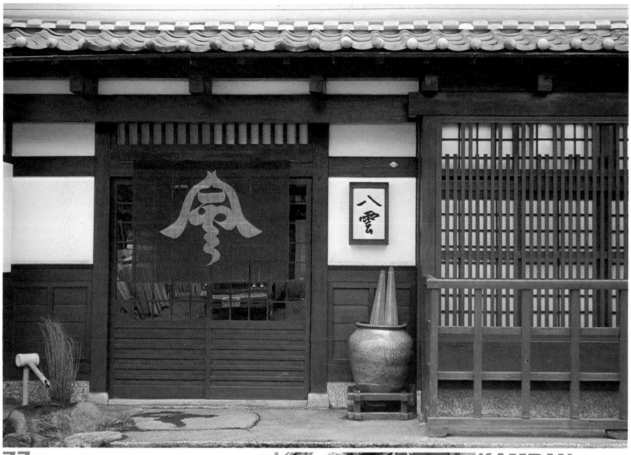

77

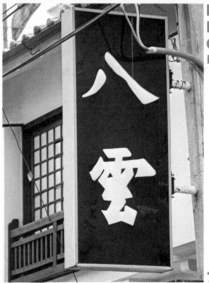

**KAMBAN
NOREN
CHOCHIN**
Nagoya

78

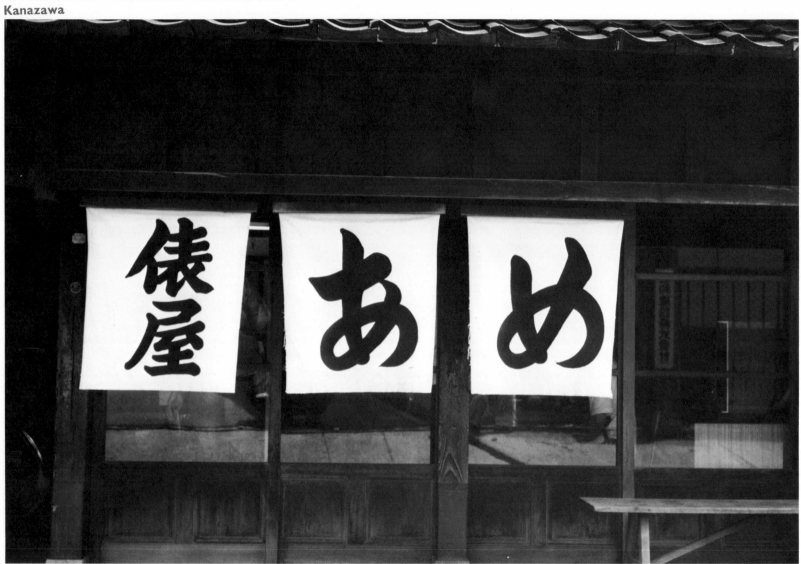

79

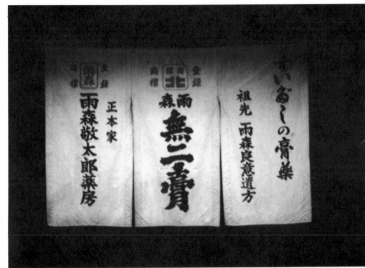

80

**KAMBAN
NOREN
CHOCHIN**
Kyoto

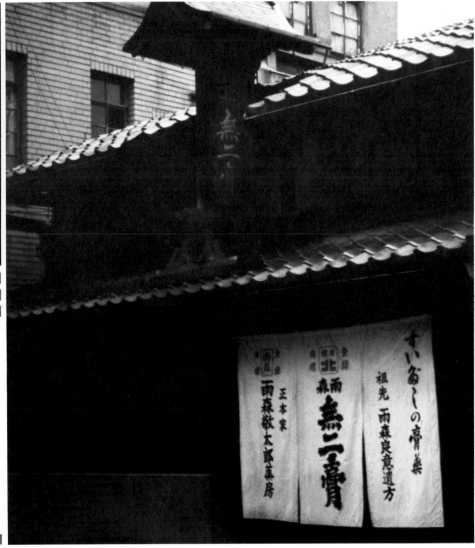

81

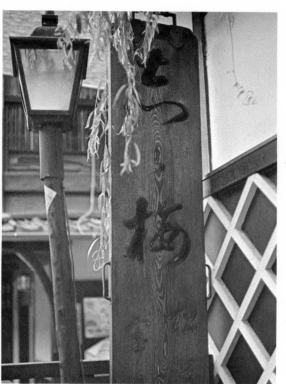

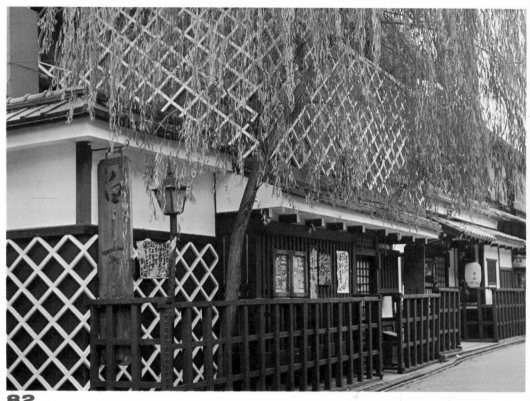

82

83

84

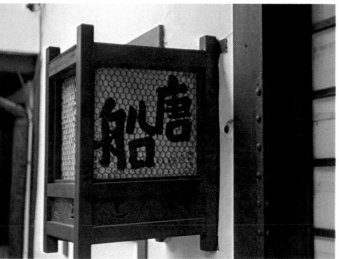

85

86

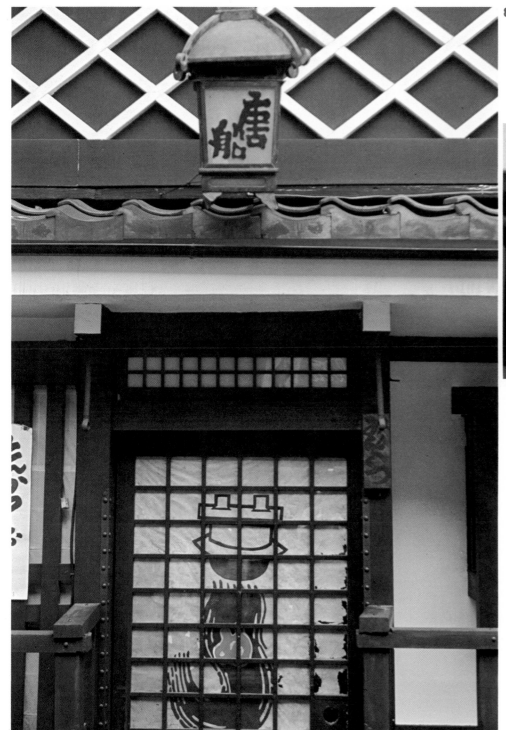

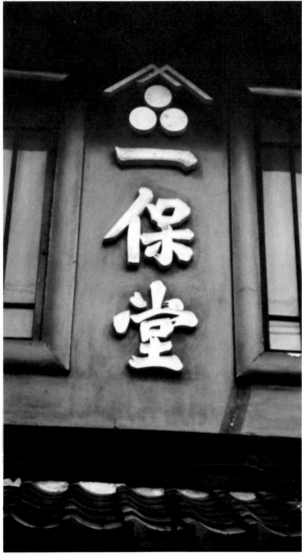

87

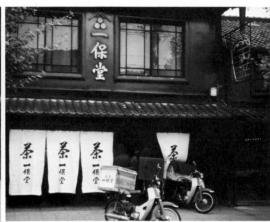

88

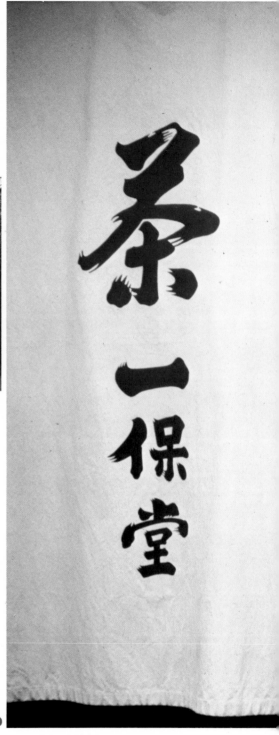

89

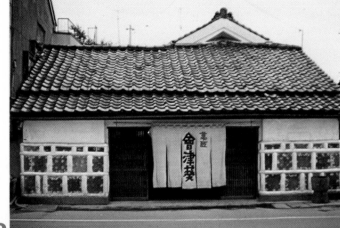

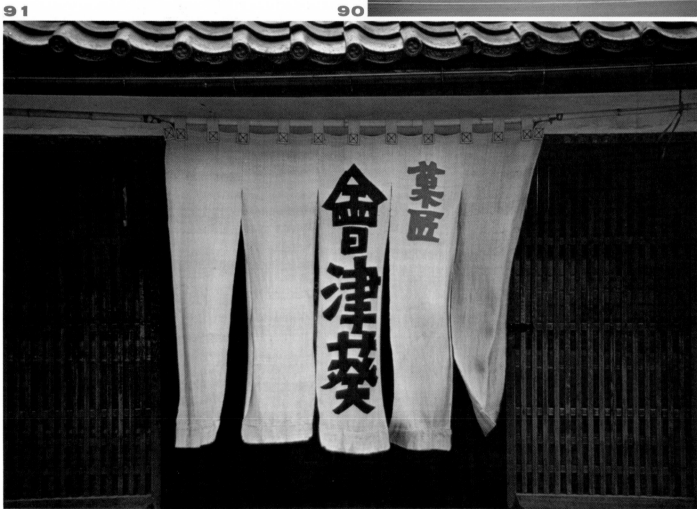

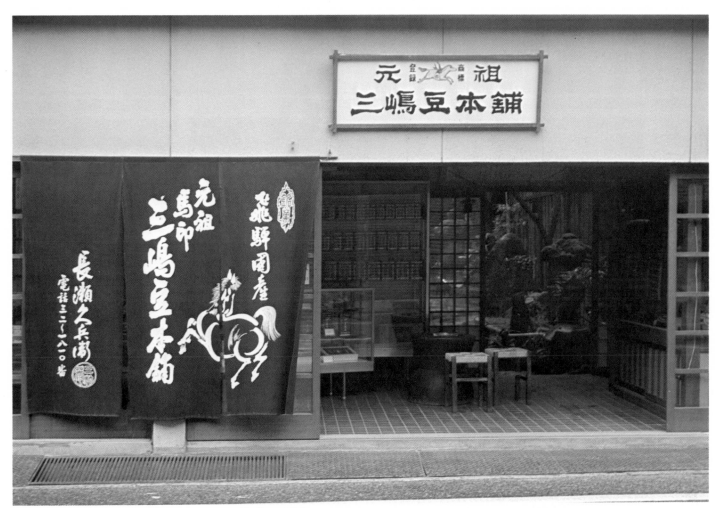

KAMBAN·NOREN·CHOCHIN
Hida-Takayama

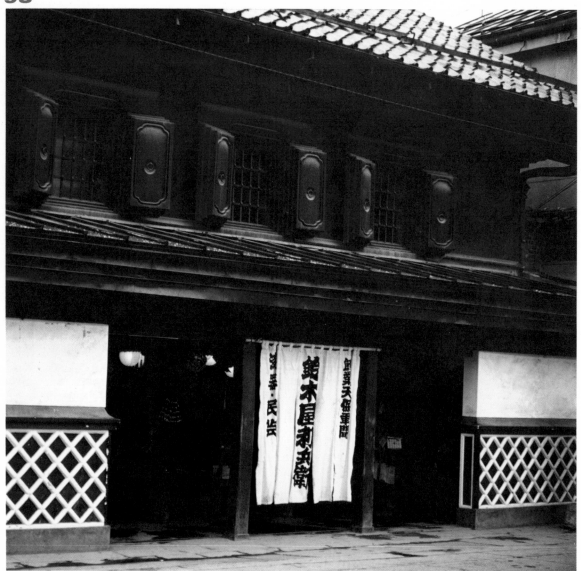

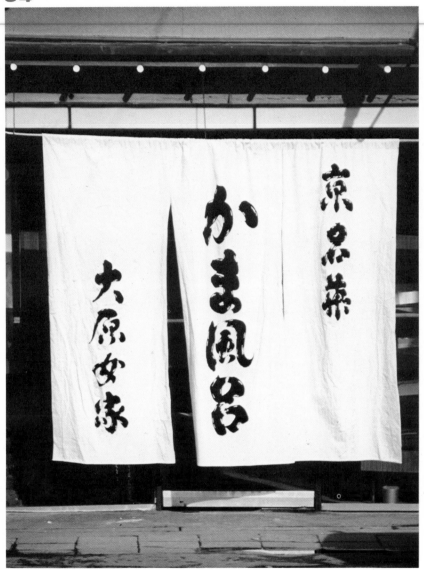

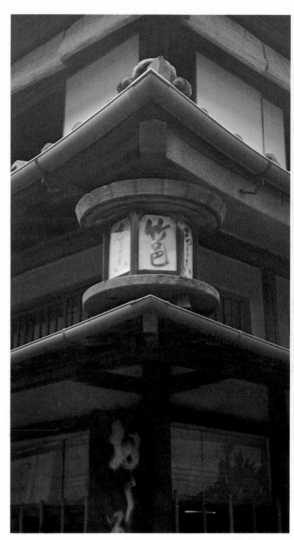

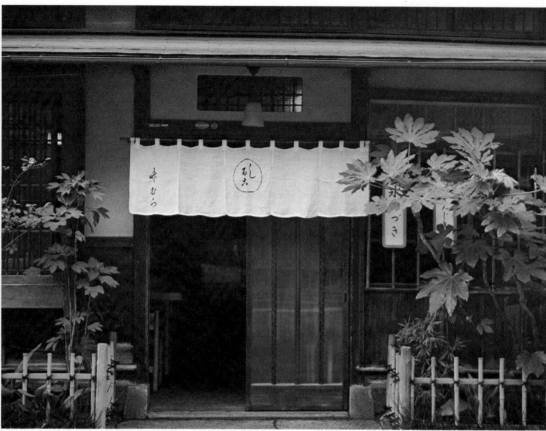

KAMBAN·NOREN·CHOCHIN
Tokyo

95

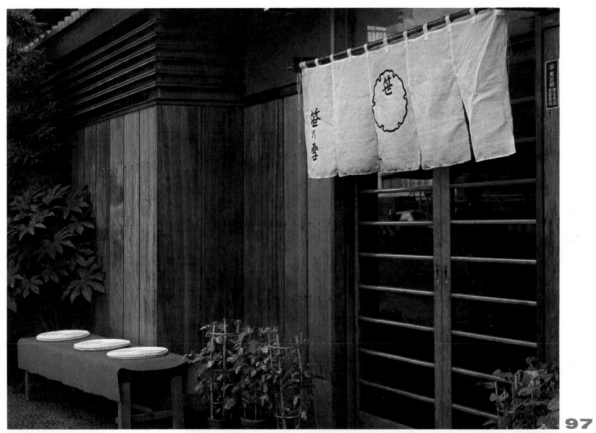

**KAMBAN
NOREN
CHOCHIN**
Tokyo

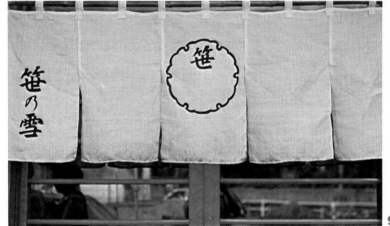

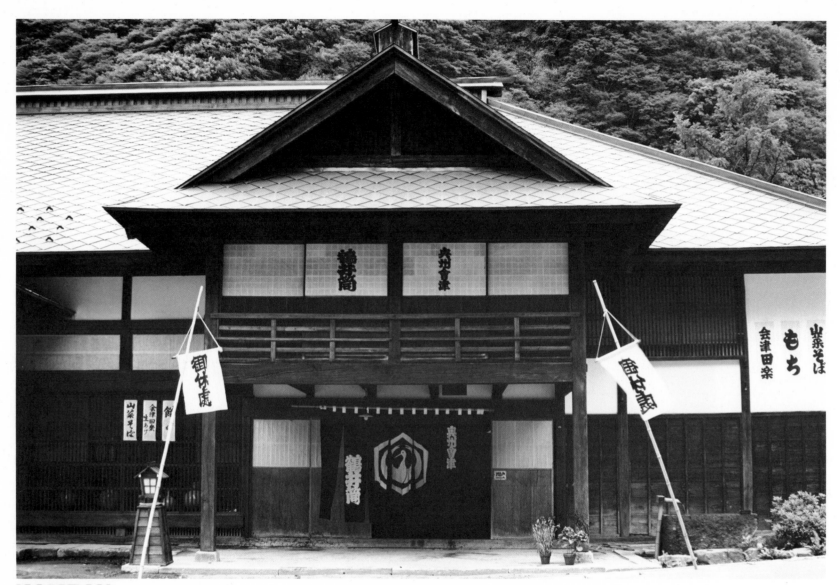

**KAMBAN
NOREN
CHOCHIN**
Aizu-Wakamatsu

99

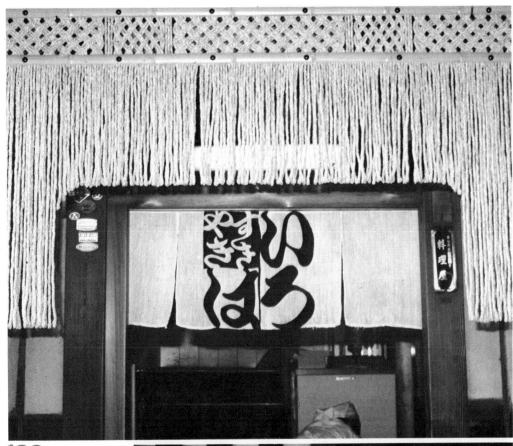

100

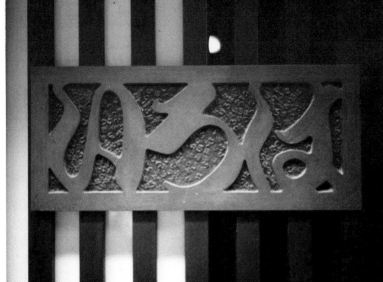

101

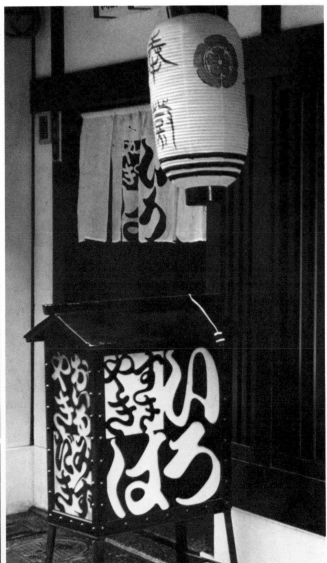

102

**KAMBAN
NOREN
CHOCHIN**
Tokyo

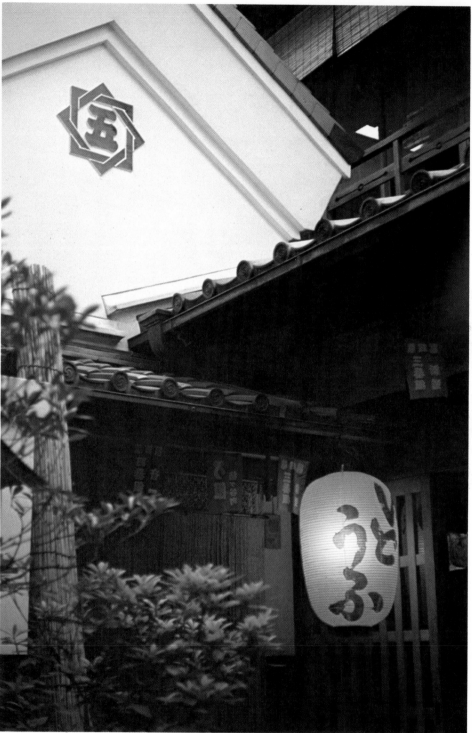

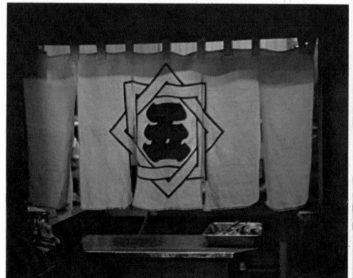

103

104

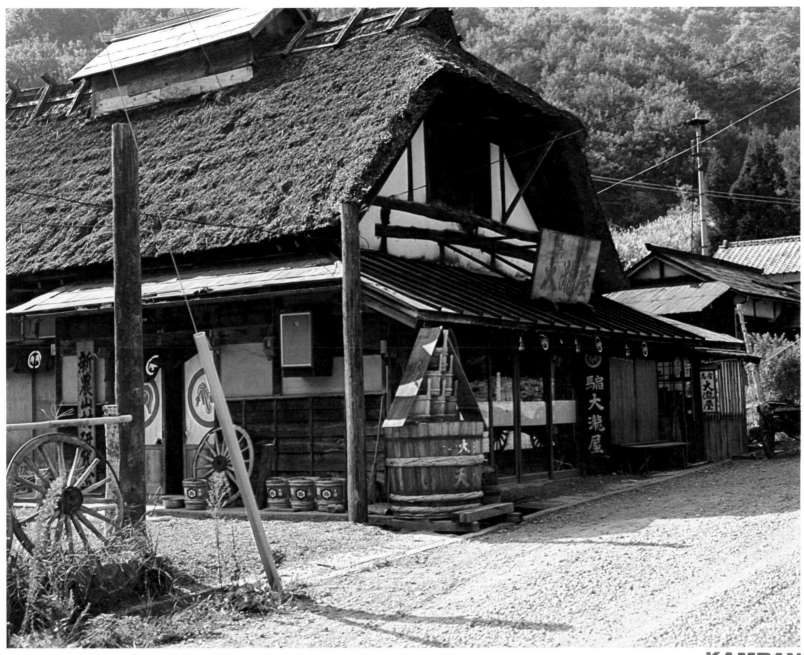

KAMBAN
NOREN
CHOCHIN
Fukushima
105

**KAMBAN
NOREN
CHOCHIN**
Tokyo

106

107

108

**KAMBAN
NOREN
CHOCHIN**
Tokyo

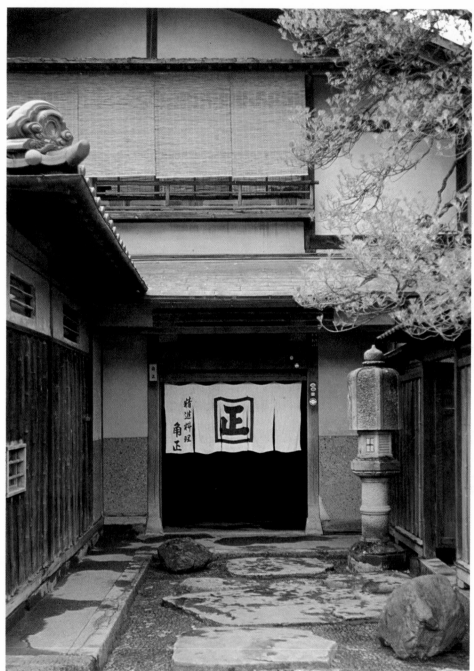

KAMBAN·NOREN·CHOCHIN
Hida-Takayama
109

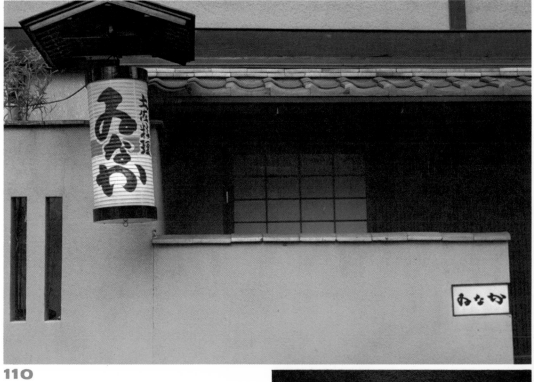

110

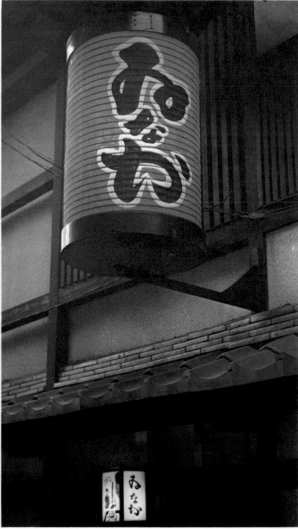

112

111

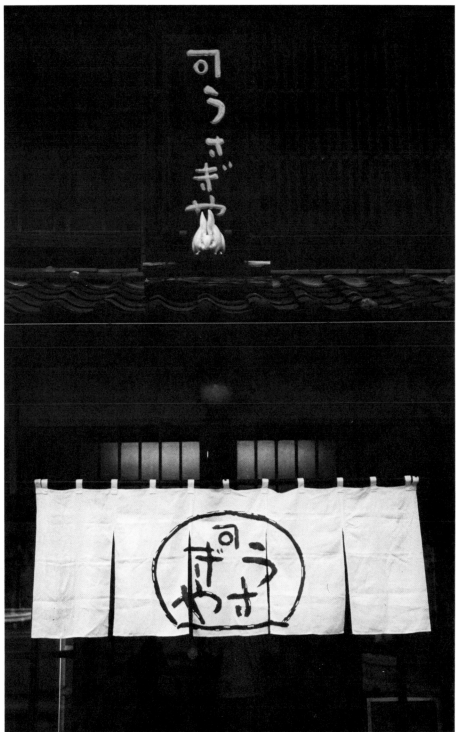

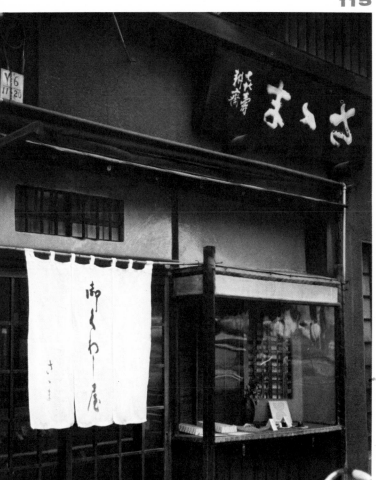

**KAMBAN
NOREN
CHOCHIN**
Tokyo

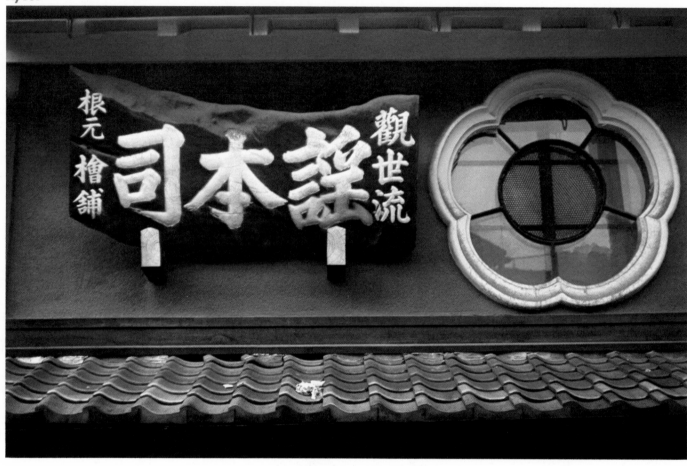

116

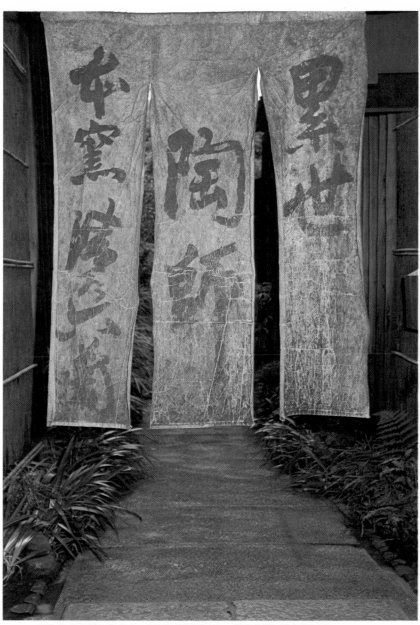

KAMBAN·NOREN·CHOCHIN
Kyoto

117

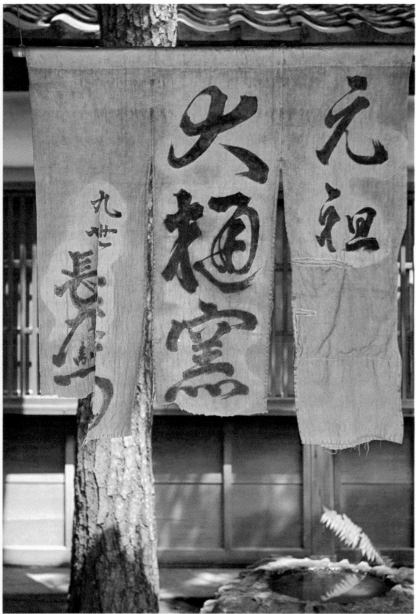

KAMBAN·NOREN·CHOCHIN
Kanazawa

118

KAMBAN
NOREN
CHOCHIN
Aizu-Wakamatsu

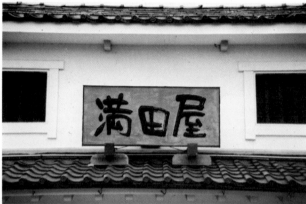

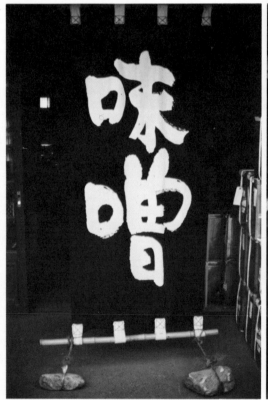

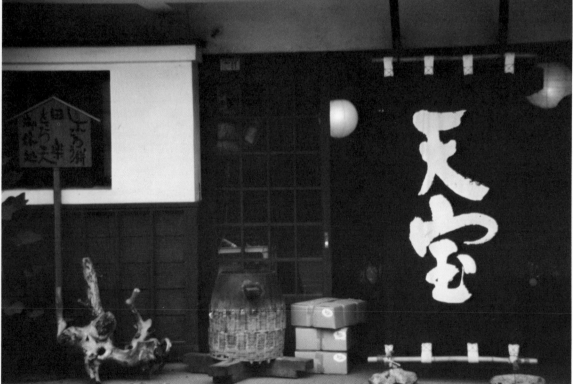

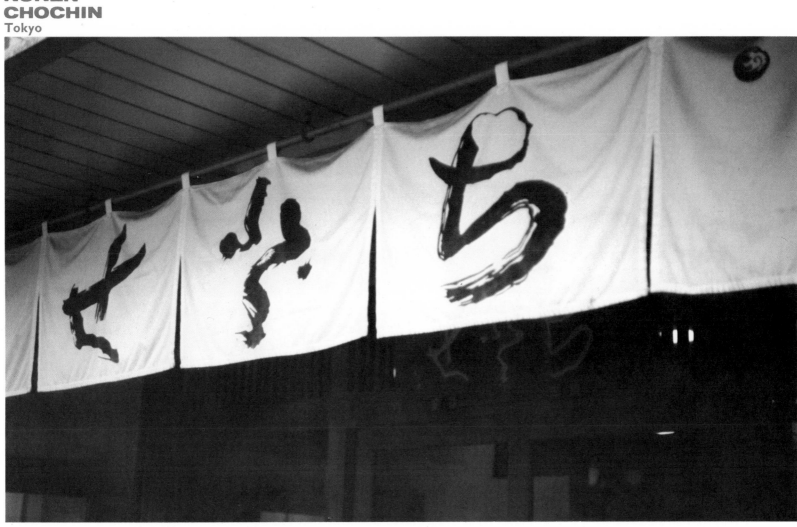

KAMBAN
NOREN
CHOCHIN
Tokyo

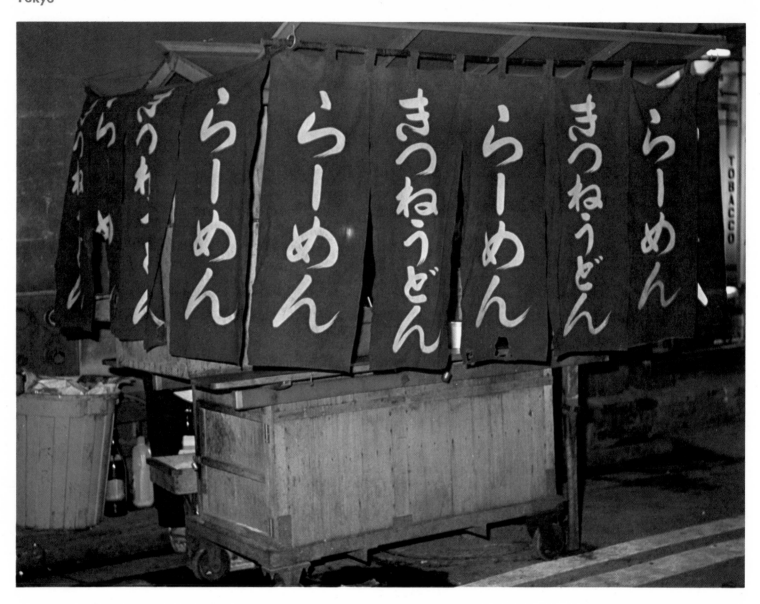

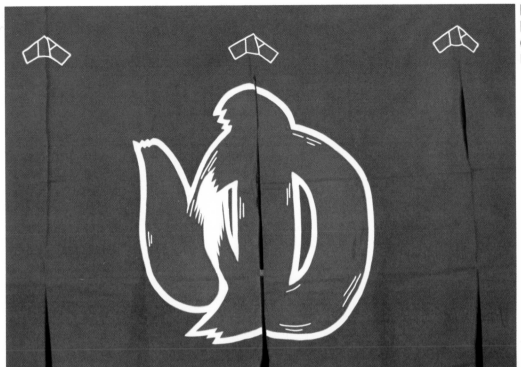

124

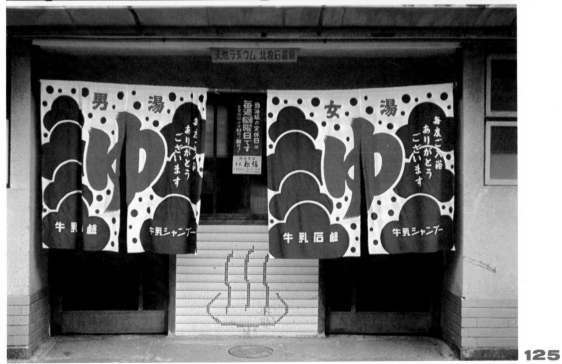

125

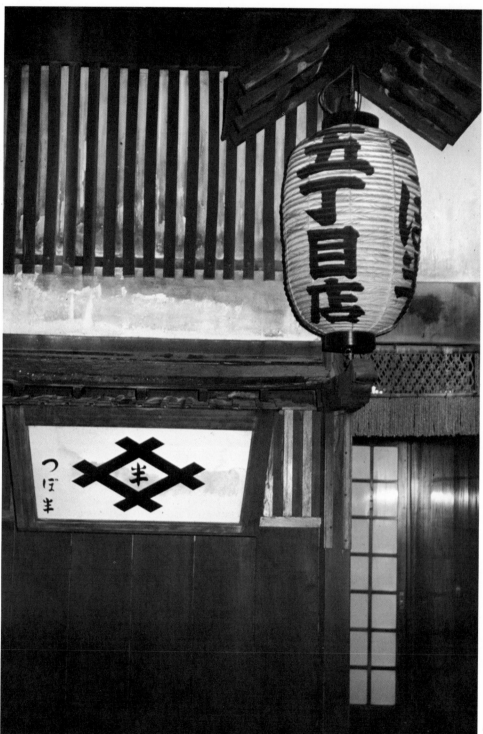

2 YANE KURA

There is a Japanese proverb that says the four things to be most feared are earthquakes, thunder, fire and father. Certainly the first three have wreaked the most destruction in Japan, where fires, whether caused by earthquakes, lightning or just plain carelessness, have been a continual source of terror. There were neither fire extinguishers to prevent the damage being total nor fire insurance to offset the loss.

Fire, then, was a most dreaded, though common, calamity when all houses were made of wood, paper, clay and thatch. Little wonder that the only possible protection seemed to be prayers and a system of sympathetic magic. On the roofs (*yane*) of houses or just beneath them it was common to see symbols and characters representing water, carved or painted as an invocation to the gods to keep the curse of fire away.

Another result of the dread of fire was the development of a separate building, more sturdily constructed, often with thick walls plastered inside and out. In this storehouse (*kura*) were kept the family treasures and the goods that constituted its wealth. In olden days, just as the *kura* was esteemed as a tangible sign of riches, so even mice, rodents much maligned in other cultures, were tolerated as evidence of prosperity. If you were poor and had no rice stored away, you could not expect mice in your house.

The building of a house with a *kura* was therefore the mark of success,

a source of pride. And as if to proclaim this pride in the family's success, it was common practice to place some sign or symbol of the family upon one or more walls of the storehouse. This could be either the family crest or a character chosen to represent the name of the family. This character, carved out of the plaster of the wall was done by unskilled laborers and is usually rough and unfinished, but the pride felt by the family in their name is reflected in the care with which the calligraphy of the character was selected. It had to be beautiful, and at the same time it had to be strong, as a more practical reason for having your name emblazoned on the walls was to show strangers to the town how to locate you quickly.

Misfortune can happen, too, and when succeeding generations ran into hard times, their houses were sold. In this way, houses and *kura* passed from family to family, and often the present inhabitants have no knowledge of the original owners, nor of the letters and symbols that adorn their walls.

It might be thought that the gods of fire would feel offended at the idea of placing invocations to them alongside the lofty emblems of the families who owned the houses, but apparently not. Rather, family pride and sympathetic magic lived comfortably side by side, and continue to do so even now.

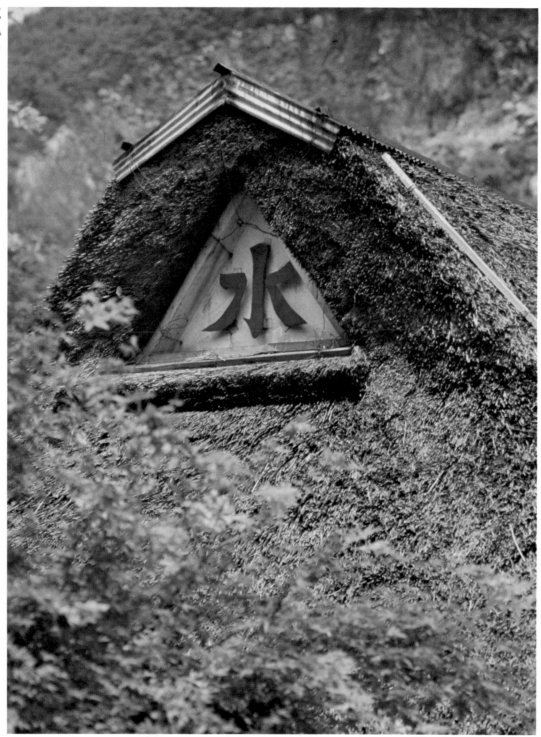

YANE · KURA

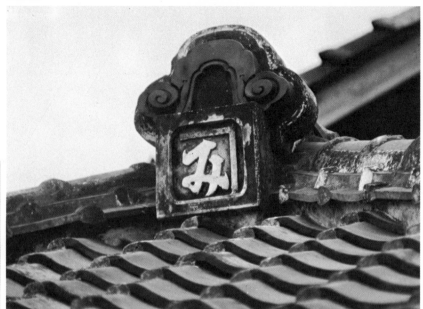

129

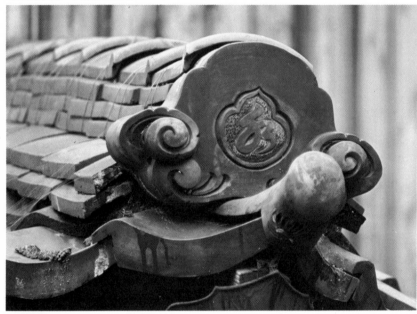

128

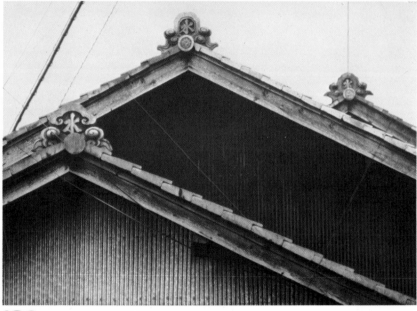

130

131

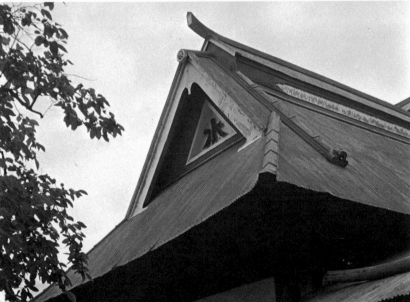

132

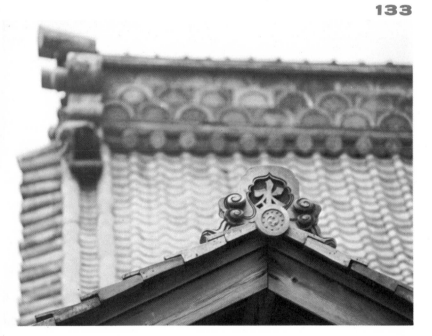

133

134

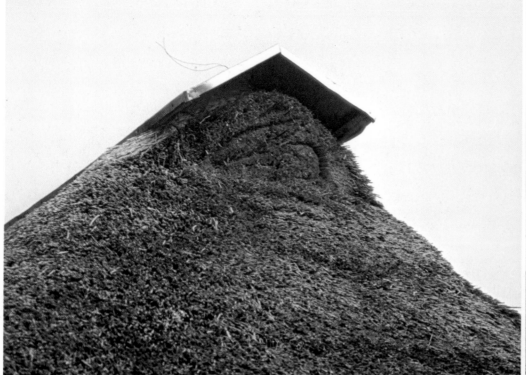

136

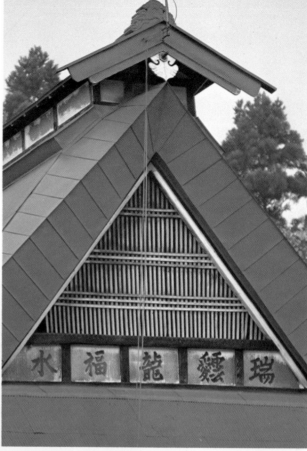

**YANE
KURA**

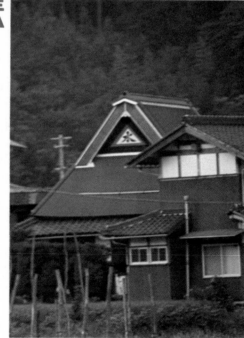

135

137

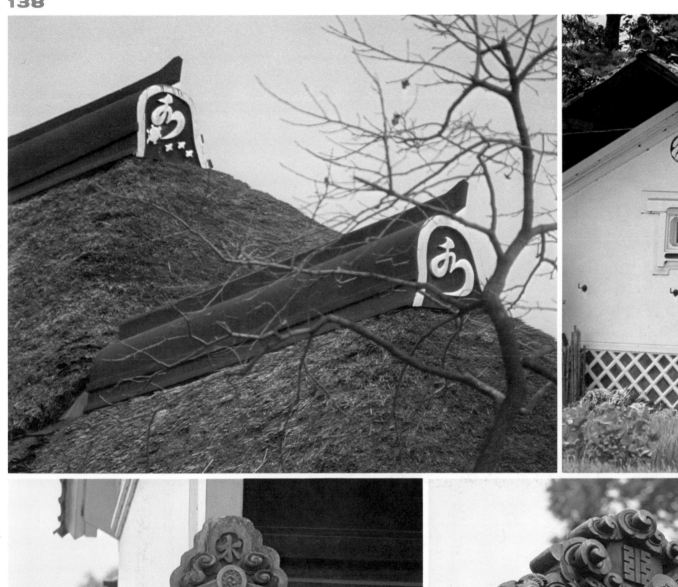

YANE
KURA
Hakuba

142

143

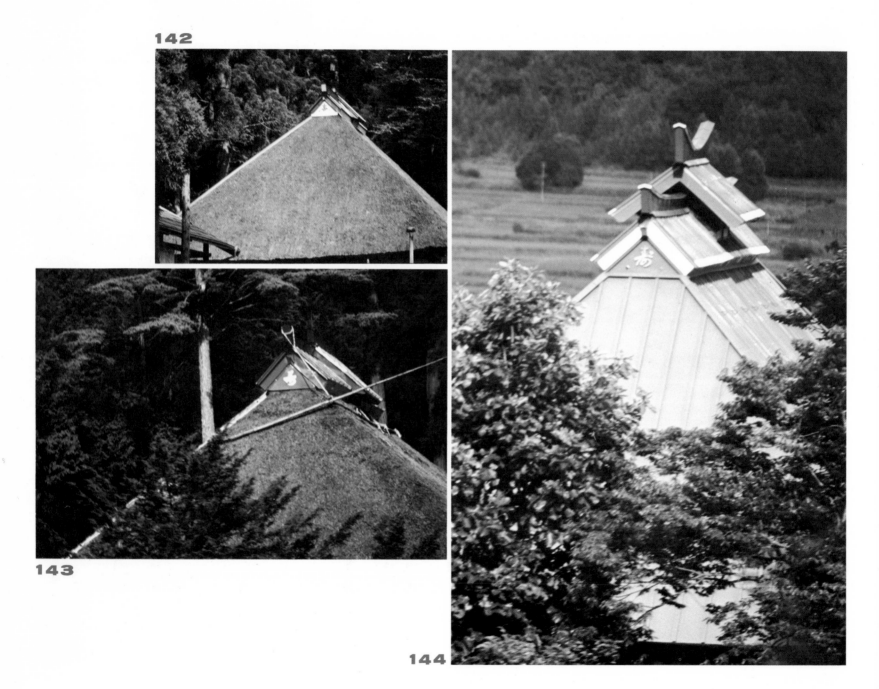

144

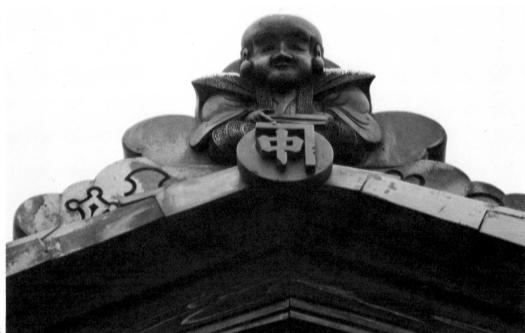

145

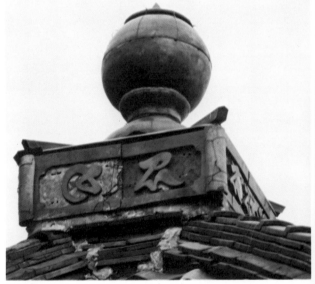

146

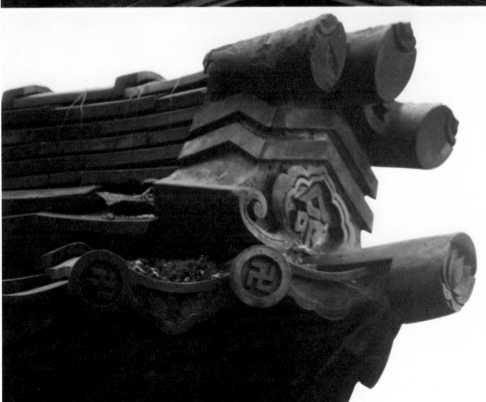

147

**YANE
KURA**
Matsumoto

149

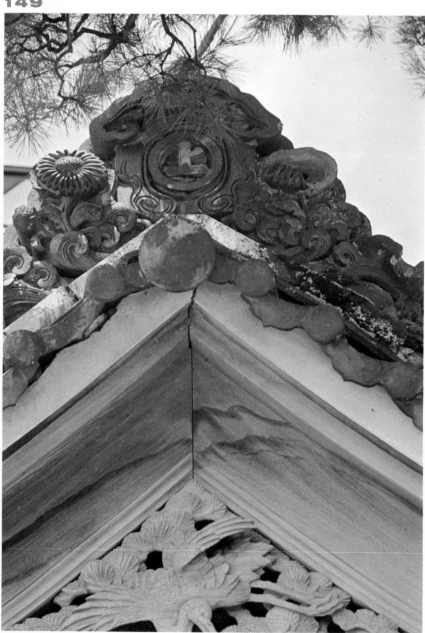

**YANE
KURA**
Hida-Takayama

148

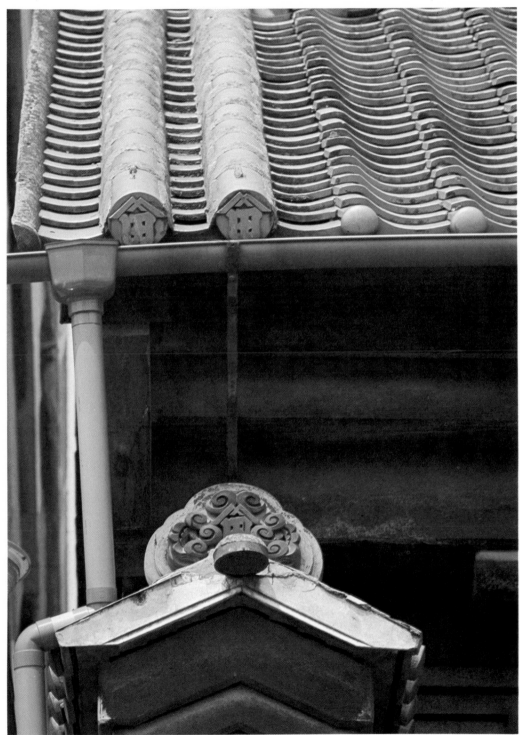

YANE·KURA
Okuchichibu

151

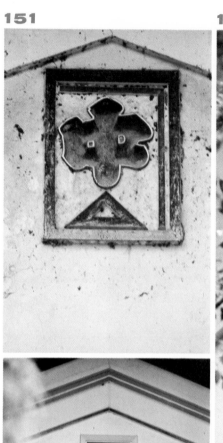

153

152

154

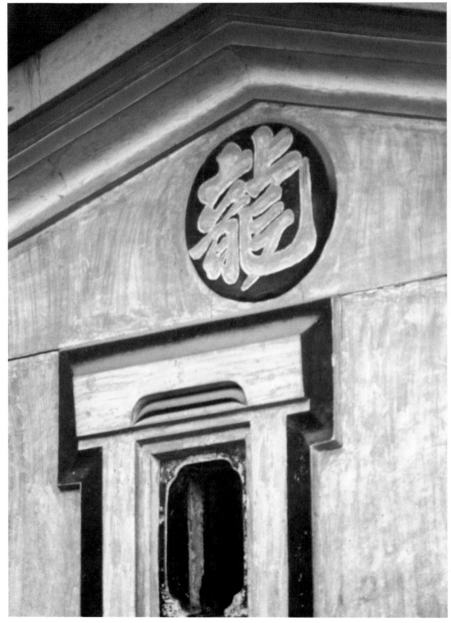

155

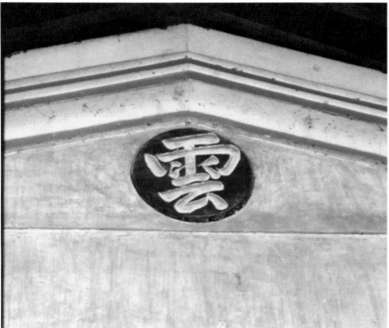

YANE KURA
Matsumoto

YANE·KURA
Okuchichibu

YANE·KURA
Okuchichibu

156

157

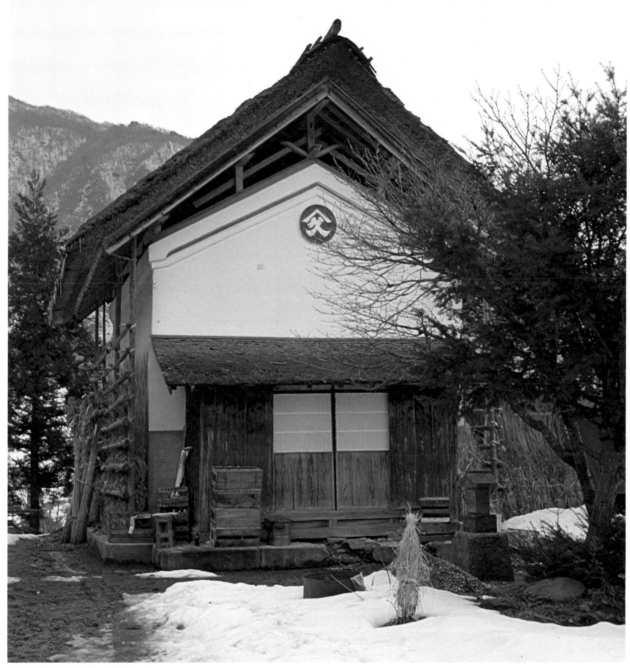

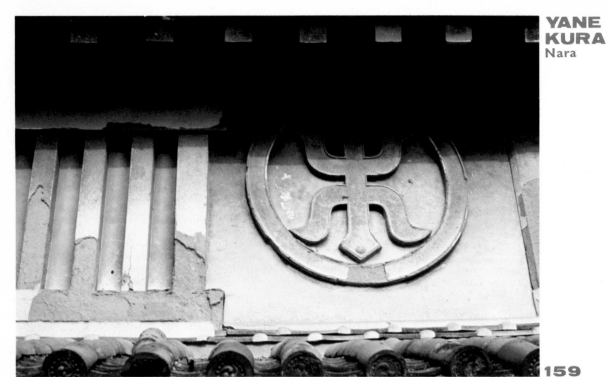

159

160

3 EMA MATSURI

The *ema* are traditional votive plaques. They may bear hopes and prayers inscribed on them or they may be offered in accordance with a vow, when a prayer has been heard by the gods and, apparently, granted. Usually they are found in holy precincts, in Shinto shrines and Buddhist temples, but even a well-known rock or a famous tree may be credited with supernatural powers and have *ema* placed beside them. For the most part these plaques use pictorial language and thus they form a living link in a very old chain.

Just as the character for water is used on a gable as a precaution against fire, so many of the *ema* are invocations, and all, of course, are magical in as much as they are dedicated to supernatural agencies. Common among their prayers are charms to keep away such misfortunes as illness and, as always in Japan, fire. Frequent also are the prayers of the crippled, the barren, the sick.

The plaques themselves are usually attractive and bright, for they must catch the eye of the deity involved—he is presumed able to read the various symbols. Often a favorite animal of the deity is included in the symbols, or some other sign he will understand. This pictorial language is readily recognizable, couched though it is in the dialect of the gods.

The gods are also involved in those lively outpourings of the spirit known as *matsuri*, "festivals." The shrines and temples are dressed up with flags and decorated with offerings, and the great portable shrines called *mikoshi* are borne through the streets. The people taking part are distinguished by their costumes and by the characters on the backs of the short coats they wear called *hanten*. Since *matsuri* originated when the festival was the only form of leisure activity available to the community, people have taken a joyous pleasure in the celebrations and in being identified with their group. The characters on the back of the *hanten* may refer to the festival itself, or they may distinguish a particular group or district to which the wearer belongs. Or, just as likely, they may denote the local brewery or carpenter's shop where he works.

The gods of Japan may well be as literate as they are benign, for they no doubt understand these various vocabularies and savor the style of each and its emotional overtones. Certainly their wards, the Japanese, are extraordinarily adept at this kind of reading. When the ability to understand these nuances disappears, Japan will be a different place and the gods will be different gods.

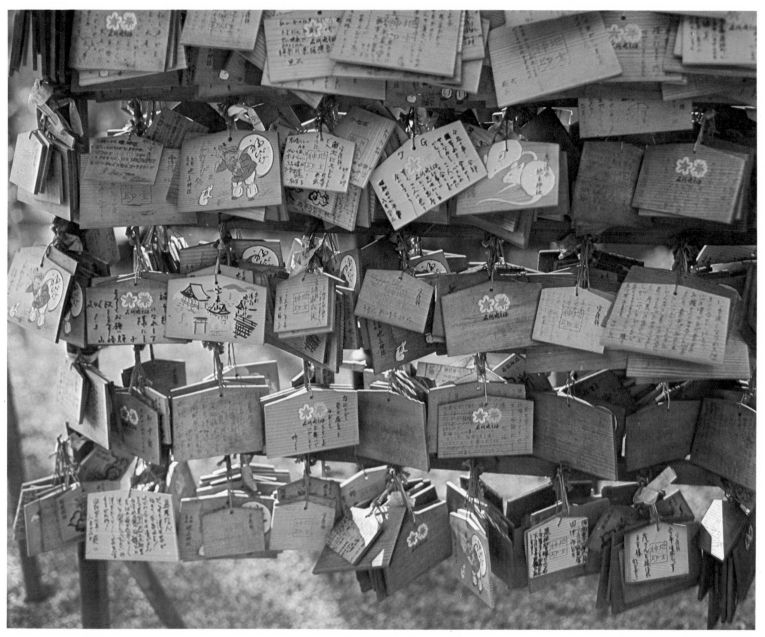

EMA·MATSURI
Kyoto

161

EMA
MATSURI
Kawagoe

EMA
MATSURI
Sendai

162

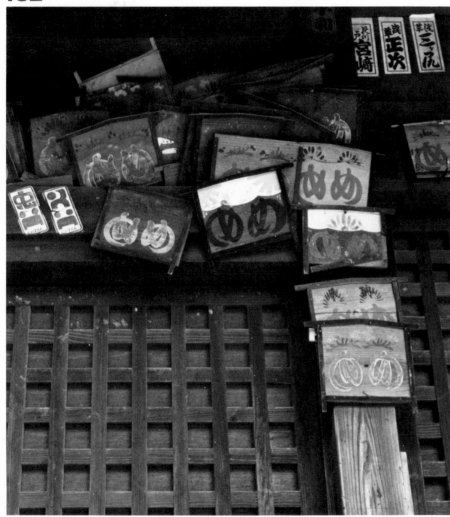

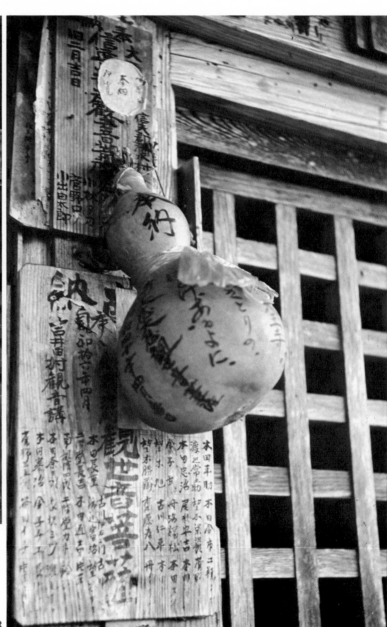

163

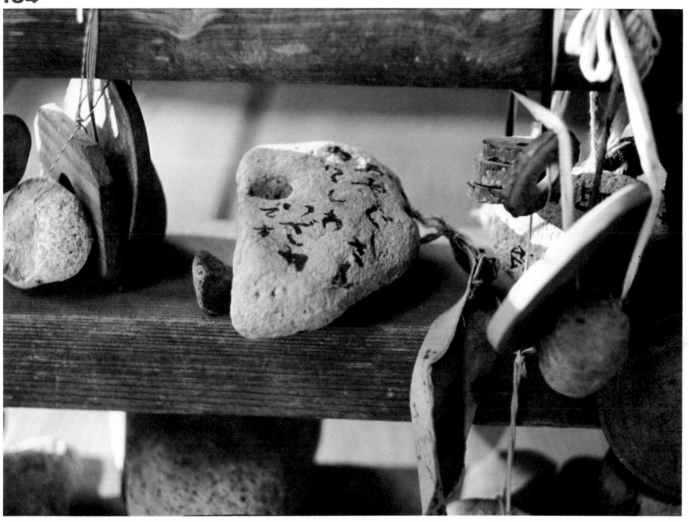

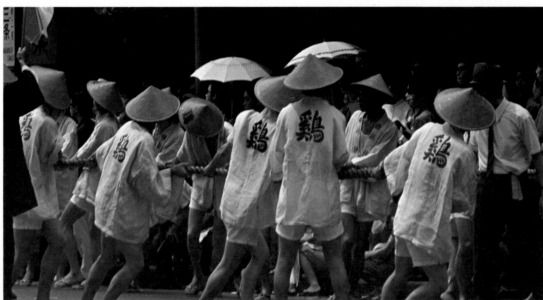

166

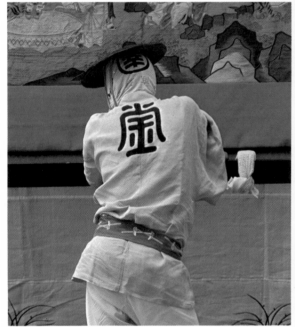

165

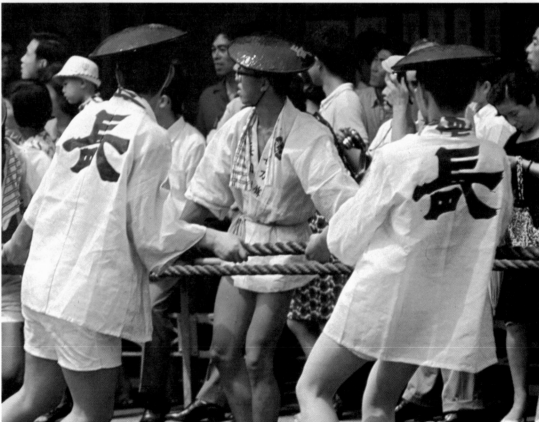

167

EMA·MATSURI
Tokyo

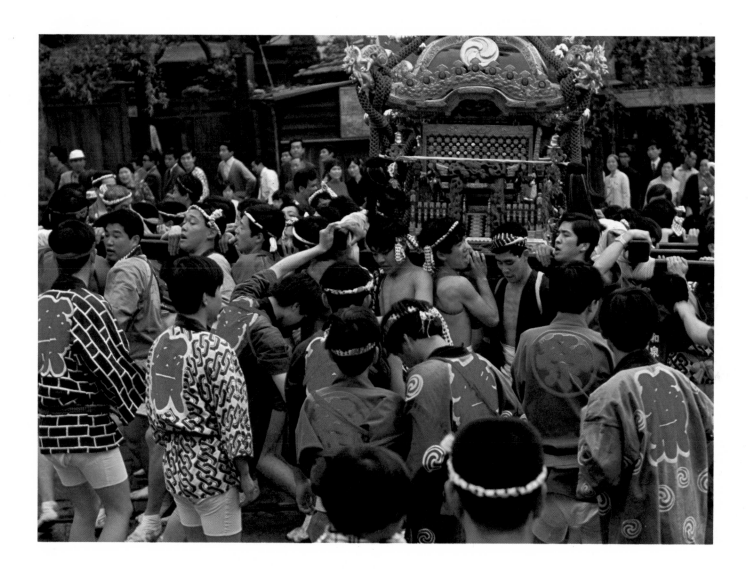

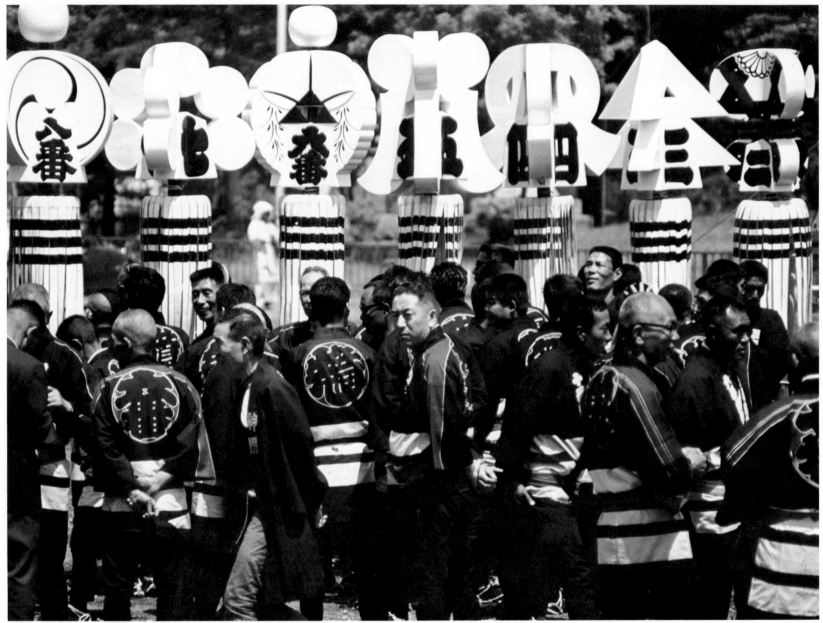

EMA·MATSURI
Tokyo

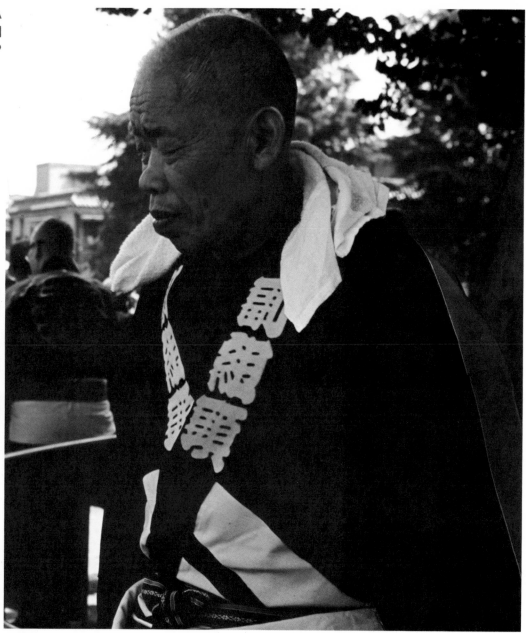

170 171

**EMA
MATSURI**
Tokyo

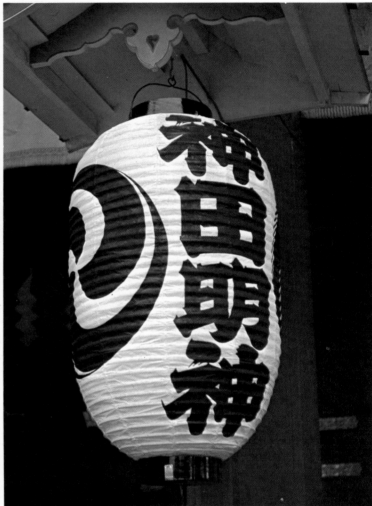

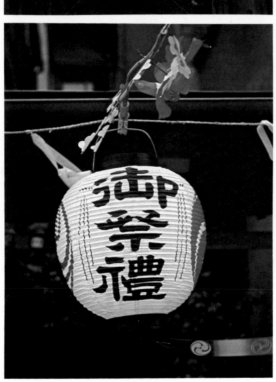

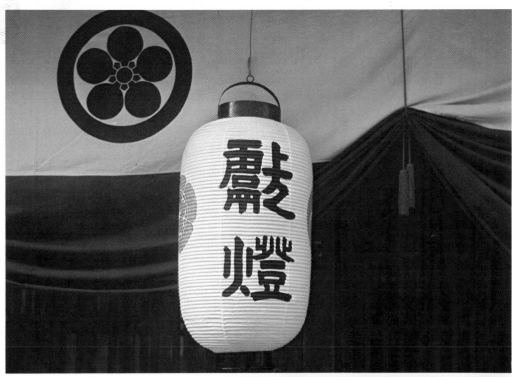

**EMA
MATSURI**
Kyoto

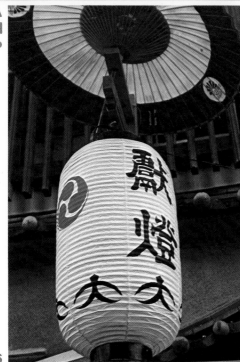

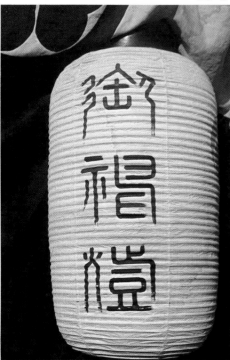

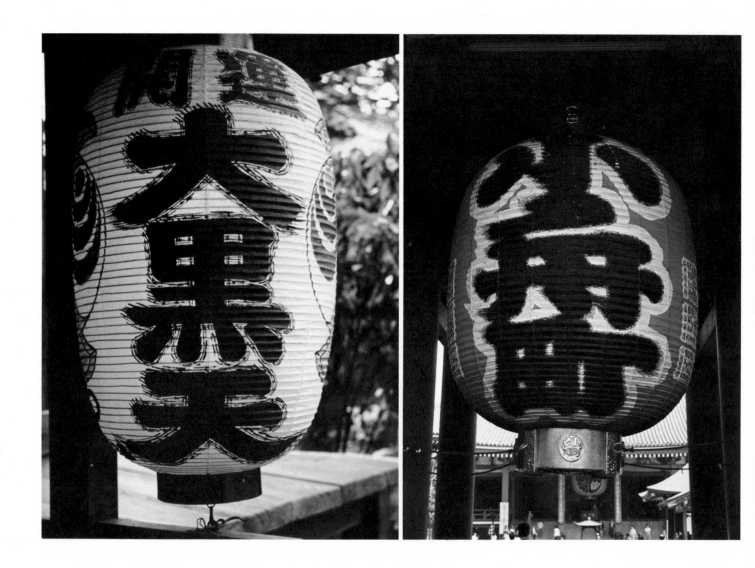

EMA
MATSURI

180

181

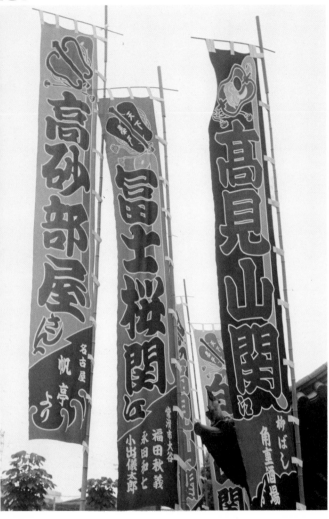

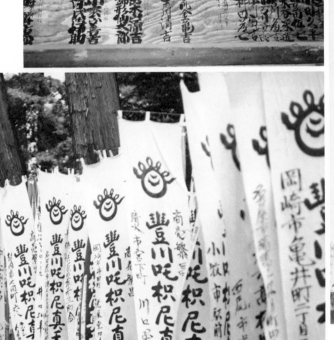

182

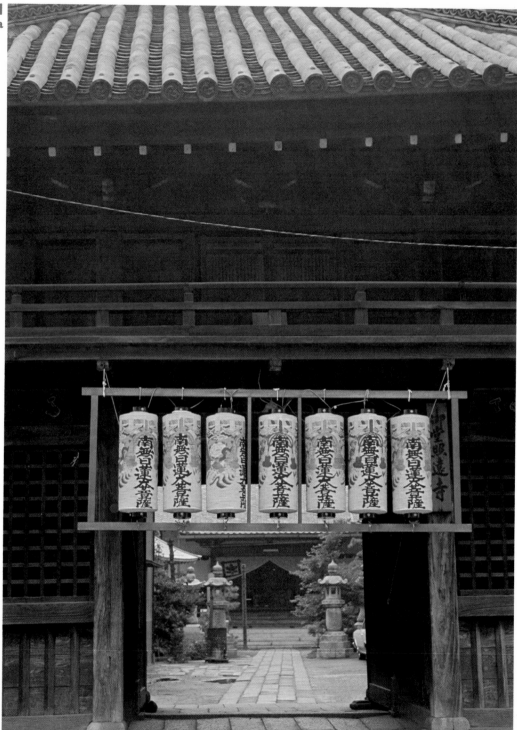

4 COMMENTARY ON THE PLATES

1. Handbag and purse shop, Kyoto.
This appealing signboard is in the shape of an old-style Japanese purse. The single red letter in bas-relief is not the name of the shop but the Chinese character *kire*, "cloth," from which these handbags are made. This kind of low-keyed representation, coupled with the elegance of the script, is typical of good taste Kyoto-style.

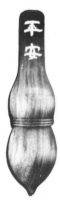 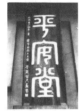

2–3. Brush shop, *Heian-do*, Tokyo.
The *kamban*, shaped like a writing brush, has the name of the shop, *Heian*, inscribed on its handle. The brush is Chinese rather than Japanese in shape, and thus gives the shop a Chinese feeling, appropriate enough in this case since calligraphy originally came to Japan from China. The impression is reinforced by the other signboard (3), where the characters *hei-an-do* are inscribed in the *reisho*, or "'Chinese seal," style. On the wall above is the emblem of the shop, which is the name written in *gyosho* style.

4–5. Musical instrument shop, *Kashiwaya*, Tokyo.
The lettering is in one of the many styles of Edo script, this one being known as *kantei-ryu*, originally associated with actors and the theater. Each character completely fills the imaginary rectangle around it, evoking visions of packed houses and great popularity. The *kamban* (5) is shaped like the sound box of the *shamisen*, the traditional stringed instrument, and again the "actor's style" is used for the letters.

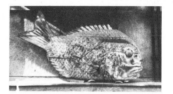

6. Caterer, Kyoto.
This caterer, famous for fish, displays a signboard in the shape of a sea bream. No name is written over the shop and the assumption is that it is an old establishment, known by everyone. This kind of sign is representative of the early *kamban*, when they bore simple symbols of the wares available inside.

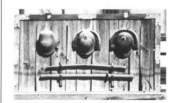

7. Antique shop, Kyoto.
The signboard, again conspicuous by the absence of any name, consists of three old helmets and two Japanese swords. It is interesting that these are actual objects rather than models. Originally this sign probably belonged to a metalworker, but its present use by an antique shop is strikingly appropriate.

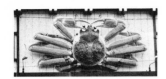

8. Restaurant, *Kanidoraku*, Nagoya.

A large and lifelike crab decorates this modern restaurant and, with the model blowfish at the left, indicates the type of food it offers. This restaurant in Nagoya is a branch of one in Osaka, and the display is typical of the showy and self-explanatory facades commonly seen in that city. This epitomizes the directness of attitude associated with Osaka, as compared to the greater preoccupation with appearances characteristic of Tokyo.

9–11. Basketware shop, *Takefuji*, Aizu-Wakamatsu, Fukushima Prefecture.

Rattanware is a principle folk art in this area and the shop front emphasizes this. The practice of writing directly on the paper of the outside panels (10) suggests the rustic and the folk. The characters, written in a variety of *Edo-moji*, spell out the articles sold and invite the customer to rest inside. The *noren* (11) bears the shop's emblem—an intertwined mark that reflects the nature of the craft. This shop curtain is the sort called *hiyoke-noren*, which is one of the earliest styles, long and weighted to stop dust from the unpaved road getting in and to keep the sun out. It is fixed at the bottom with rocks to prevent it flapping in the wind, an inconvenience perhaps for customers who have to go around it but another touch that adds to the old-fashioned feel of the place.

12–13. Restaurant, *Tsutaya*, Okusaga, Kyoto.

This is one of Kyoto's more celebrated fish restaurants, specializing in sweetfish. Situated outside the city, it backs onto a river where the fish is caught. The calligraphy on the lantern (13) is in *gyosho* style, written by the owner, and is much admired as reflecting the delicate flavor of the food served.

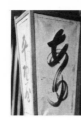

14–16. Restaurant, *Hiranoya*, Okusaga, Kyoto.

Near the restaurant above is this other, with the same fish as its speciality. Its round lantern (16) has the shape of a fish trap. The paper is treated with persimmon juice to achieve that particular shade associated in Kyoto with elegance, leisure, worth. The square lantern bears the name of the restaurant on the front, with *ayu*, "sweetfish," written on the side (shown also in the detail, plate 15). The characters are formed with a strength and vitality characteristic of the fish itself and at the same time they suggest something of the spare elegance of this aristocrat of table fishes.

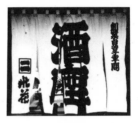

17. Sake shop, *Konohana*, Aizu-Wakamatsu, Fukushima Prefecture.

Originally a sake merchant's shop, this is now a private museum of objects related to sake. The shop curtain is old and extremely fine. The script is *kago-moji*, a slightly abbreviated Edo-style variety that is bold, black, and strong. Like the *kantei-ryu* style, it has associations of crowds and popularity, and was often used by establishments aiming for this. The fact that the lettering says *sakaza* instead of the more contemporary *sakaya* suggests something satisfyingly historical to the modern Japanese.

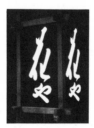

18. Restaurant, *Hanaya*, Tokyo.

This lantern, despite its traditional shape, has a very modern feeling because the characters of the name of the shop are in an eclectic modern style known as *gendai-gyosho*. The effect is one of sophistication and luxury, but of a contemporary kind.

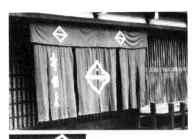

19–20. Sake shop, *Utsuboya*, Hida-Takayama, Gifu Prefecture.

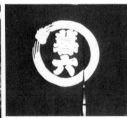

This famous sake shop has now been turned into a sake museum. Its shop curtain is a unique combination of two different types: the short *mizuhiki* style, now common everywhere, and the old-fashioned, long *hiyoke-noren* style. The house mark is a sort of box, an old-style measure for sake, seen from above and thus diamond-shaped, with the spout hole shown in the upper triangle. This motif is echoed in the triangular placement of the emblems on the curtain itself (19), the larger one being in the middle of the lower part while the two smaller ones are in the upper right and left. The emblems are striking and simple, yet it is their arrangement and the colors used that make this *noren* so well known and admired. Dark blue was the color usually associated with sake dealers and the use here of dark brown is regarded as *iki*, the Japanese equivalent of "chic." This quality is characterized by an exquisiteness of selection and by simplicity, a taste that has been cherished throughout Japanese history.

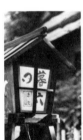

21–22. Restaurant, *Kuremutsu*, Tokyo.

The shop curtain of this restaurant demonstrates stylized elegance. The characters show two varieties of *Edo-moji*: the two characters for *kure* and *mutsu* are encircled by another letter that is in *hige-moji*, a style that translates as "whiskered lettering." This circular letter is read *tsu* and is the *kana* symbol for that sound. Thus, the *tsu* of *kuremutsu* is repeated, the final syllable wrapping up the name in the most literal fashion.

In Japan, however, where such practices are common, this is not regarded as whimsical but rather as a clever means of creating a house emblem. An additional note of playfulness is contributed by the lantern (22), though in an entirely traditional manner. For, while being orthodox in shape, a crescent moon has been cut out of its side—a graceful reference to the name of the restaurant, since *kuremutsu* is an old word for early evening, just the time when a crescent moon would appear.

23–35.

The following thirteen plates depict the signboards, curtains and lanterns of various *sushi* shops. *Sushi* is an Edo delicacy, originally a somewhat plebeian food that has now become popular and expensive. Basically it is a ball of rice topped with a slice of fish, usually raw. It is flavored with horseradish paste (*wasabi*) and eaten after being dipped into a little soy sauce. Though all cities have this food and their own particular variations, it is Tokyo *sushi* that is most typical and most appreciated.

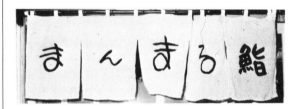

23. *Manmaruzushi*, Tokyo.

The lettering is *gendai-moji*, modern and rare for a *sushi* shop, but the feeling is traditional.

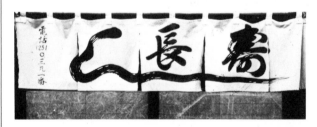

24. *Nagazushi*, Tokyo.

Naga is in *gyosho* style, indicating tradition and elegance, while *sushi* is in *hige-moji*, an Edo style of strength and purpose, suggesting that the establishment knows its business and tolerates no slackness.

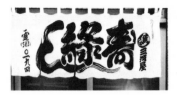

25. *Midorizushi*, Tokyo.
This lettering is also in bold *hige-moji*.

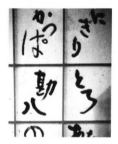

26. *Kampachi*, Tokyo.
The letters are all contemporary in style. The square in the center of the second row from the top is the name of the restaurant while the others are the menu, written directly on the *shoji* paper and thus giving the place a very rustic touch.

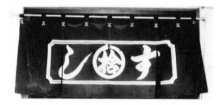

27. *Sutezushi*, Kanazawa, Ishikawa Prefecture.
The circled character is *sute* and the *kana* syllables are those for *su* and *shi*. The *kaisho* style of lettering makes the feeling traditional.

28. *Sushiko*, Tokyo.
The modern lettering adds an air of efficiency to a traditional atmosphere.

Words in Japan may be written in a variety of ways. A number of *kanji* can be read with the same sound, and thus a number of variations are possible when writing, for example, *sushi*. In plates 24, 25 and 28, we have the *shi* written in *hiragana*, while the *su* is a Chinese character that may also be read as *kotobuki*, "felicitations." In plate 23, we have a more standard reading, with the two characters of *sushi* being, on the left, *sakana* ("fish"), and, on the right, *umai* ("good," "skillful," "delicious"). Thus the alternate meaning of *sushi* in this reading is obviously "Fish tastes good." The Chinese characters in plates 24 and 25 are not only in more traditional script, but the reading is in the traditional manner, from right to left. The reverse, from left to right, is suggestive of the present day rather than the past. The following plates are also examples of *sushi* shops and their varied styles of presentation.

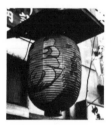

29. *Uoharuzushi*, Tokyo.
Here the calligraphy is in traditional *hige-moji*, and instead of a *kamban* a lantern is used. To the Japanese the sight of a red lantern means a congenial atmosphere that is not too expensive. There is, moreover, an air of transience and of impermanence about an establishment bearing a red lantern that makes its associations such pleasures as chance meetings and spur-of-the-moment indulgences.

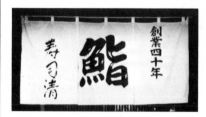

30. *Sushikiyo*, Tokyo.
The calligraphy is in standard *gyosho*, and, as though to insist upon the soundness implied by this script, the right side of the curtain states that the shop was founded forty years ago.

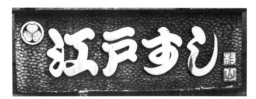

31. *Edozushi*, Tokyo.
Here a *kantei-ryu* style script is used, common for *sushi* shops located in the Ginza–Tsukiji area near the main fish market of Tokyo. The message of sound service is backed by a wooden board with gilt letters, an ornate style unusual for *sushi* shops.

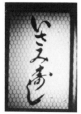

32. *Isamizushi*, Tokyo.
Again the signs show traditional calligraphy, together with a drawing of the ceremonial ribbon used to tie presents. The implication is that this is an old restaurant so well thought of that one may safely make valued gifts of its food.

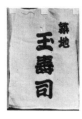

33. *Tamazushi*, Tokyo.
This *noren* is more novel: around the writing in *kantei-ryu* style are prints of sea bream, made from ink rubbings of the fish. Known as *tai* in Japanese, this fish is often used as a felicitous ceremonial food because its sound is the same as the final syllable of the word for "auspicious," *medetai*.

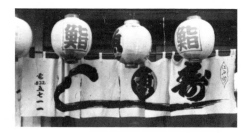

34. *Edomaezushi*, Tokyo.
Not only are the traditional associations of old Tokyo present in the name, *Edomae*, but the name of the old quarter of Uogashi is written on one lantern. Black and red are the colors reminiscent of this neighborhood, for in olden days the clothes of laborers who worked there were in these colors.

35. *Kampachi*, Tokyo.
This is the same shop as in plate 26 and again a carefree, informal feeling is intimated by the modern lettering and the whimsical design in which a rice ball becomes a face and the slice of raw tuna on top becomes a hat. This is painted casually on the glass window of the shop.

36–40.
Other fish shops are illustrated in the next series, particularly those specializing in *unagi* (eels) and *dojo* (mud fish). While such restaurants may be both old and elegant, the fare is looked upon as basically plebeian, and a dinner there is approached in a different frame of mind than a complete Kyoto-style meal. Eels are most popular in midsummer, when they are believed to offset the debilitating effects of the heat. Mud fish are found in rice paddies and so are commonly regarded as country food.

36. Fish restaurant, Tokyo.
The advertising medium is a large banner usually associated with rural restaurants. Adding to the easygoing feeling is the variety of writing styles shown on it. A *gyosho* script is used, but the word *unagi* is written differently from the words around it. The result is an interesting and pleasing stylistic combination.

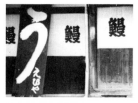

37. Eel restaurant, *Ebiya*, Aizu-Wakamatsu, Fukushima Prefecture.
This is an old and famous restaurant. Doors half-wood and half-papered are representative of old Edo, as is the *kago-moji* script used. On the *noren*, the *u* of *unagi* is drawn in the shape of the fish, a typical Edo period touch.

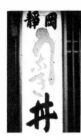

38. Eel restaurant, Akita.

In this kind of restaurant one can either buy cooked eels to take home or one can eat them there. Either way, sake is usually drunk at the same time since eel is a particularly oily, if tasty, dish. This shop indicates this custom by displaying three sake barrels directly over a sign announcing their *unagi-donburi*, "eels over rice."

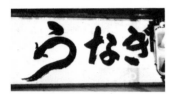

39. Eel restaurant, *Kikukawa*, Tokyo.

Unagi appears in various combinations on this store front. The first *u* in the white section is in the shape of an eel.

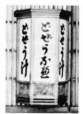

40. Fish restaurant, *Komagata*, Tokyo.

This restaurant specializes in mud fish. On the curtain the *gyosho*-style calligraphy has *dojo* written as *do-ze-u*, the old-fashioned spelling, thus implying a degree of tradition and down-to-earth value.

41–48.

The following plates are of *soba* shops. *Soba* and its thicker near-cousin *udon* are strips of dough cut thin and boiled. Both are staple foods in Japan and occupy a position similar to their descendant, spaghetti, in Italy.

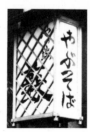

41. Soba shop, *Yabusoba*, Tokyo.

The *gyosho* script, the old-style lantern, the lattice-work on the side—all speak of tradition and the good old days.

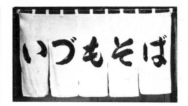

42. *Soba* shop, Izumosoba, Tokyo.

This is a typical facade in that the most important element, the *kamban*, is written mostly in formal *kanji*, while the subsidiary *noren* and *chochin* are allowed the more relaxed *kana*. The implication is that the signboard stands for the house, while the curtain and lantern are nearer to advertisements, even though the same message is written on each.

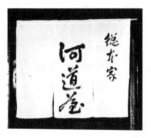

43. *Soba* shop, *Kawamichiya*, Kyoto.

Old and well-established, this shop is typically Kyoto in that the *gyosho* calligraphy of the *noren* is done with a delicate care for aesthetic effect, intimating that the customer will be accorded the best personal service and that great attention is paid to niceties. The calligraphy is crowded together toward the bottom of the *noren* indicating a Kyoto attitude of respect as regards the client.

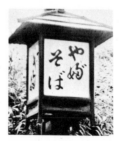

44. *Soba* shop, *Yabusoba*, Tokyo.

The lettering on the signboard is in *reisho* and that on the lantern is in *gyosho*. This combination is considered both beautiful and fitting in such a famous shop as this.

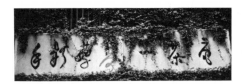

45. *Soba* shop, *Issa-an*, Tokyo.

The *kamban*, set off by ivy, says, *Te Uchi Soba Issa-an*, which means that all the noodles in the restaurant *Issa-an* are made by hand. Despite the commercial sound of the message, the *sosho* style of calligraphy and the general air of gentility suggest that this is one of the places where, though the helpings may be elegantly modest, they will be excellent in taste. The informality is unpretentious; the restaurant knows its worth and so does the clientele.

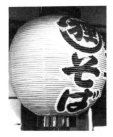

46. *Soba* shop, *Mamianasoba*, Tokyo.

The lantern is typical and rather ordinary as far as the color and calligraphy goes, and the uniqueness lies in what it says. There is a variety of *soba* known as *tanuki-soba*, named after the badger (*tanuki*). Statues of this popular animal are often found outside *soba* shops. Here the lantern states that *tanuki-soba* is to be had within, but the fillip is that the letter *mami* in the shop name can be read *tanuki* as well. It is this kind of visual pun that the Japanese find irresistible, and following the delight of comprehension, it is confidently expected that the passerby will come into the shop.

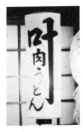

47. *Udon* shop, *Kano*, Tokyo.

This shop insists on the lower-class and rural associations of its noodle speciality, hence the conical hat made of sedge that hangs outside. The rustic impression is enhanced by the apparent artlessness of the *gyosho*-style lettering on the lantern and the menu written on little wooden plaques to the left, which can be changed as required.

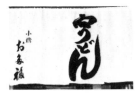

48. *Udon* shop, *Otafuku*, Kanazawa, Ishikawa Prefecture.

In the middle of the white curtain the word *udon* is written in a combination of styles: the *u* of *udon* is in old-style *hentaigana*, while the other two letters are in modern *hiragana*. The effect is modern, graphic, and envisages a combination of old-style cooking with modern efficiency.

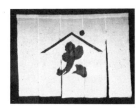

49. Former restaurant, *Yamadai*, Hida-Takayama, Gifu Prefecture.

Though this building is now a private house, the beautiful and striking curtain of the former Japanese-style restaurant has been preserved. The single character *dai* is written in the old *hige-moji*, but the other part of the name is not written but pictorialized. *Yama* means "mountain" and so over *dai* has been drawn the outline of a mountain. The effect is arresting, and the assumption is that the restaurant is so well known that no one should have any difficulty "reading" this combination of character and picture.

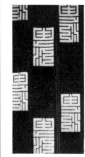

50–52. *Ochazukeya*, *Junidanya*, Kyoto.

Ochazuke, generally a lower-class dish though in Kyoto customarily the final course of the elegant *kaiseki* cuisine, consists of rice with green tea poured over it, served with pickles. This famous restaurant of Kyoto, whose name means "Twelve Steps," now serves *shabu-shabu* —the Japanese *pot-au-feu*—and other dishes. The building has several entrances; the private one (50) has a black and white curtain, narrow in the seemly Kyoto

style, with the name written in Chinese-style *kaku-moji*. The signboard (51), read from right to left in the old way, uses the *kantei-ryu*, redolent of popularity and good times.

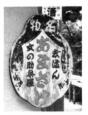

53. Sweet shop, *Bunnosukejaya*, Kyoto.
Amazake is a weak, sweet drink, popular with the young. Here the word is spelled out in large red characters that have a pleasantly childish feeling about them, particularly in conjunction with the face of Okame, a folk character associated with homely cheerfulness.

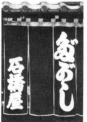

54–55. Sweet shop, *Ishibashiya*, Sendai, Miyagi Prefecture.
The name of the shop is written in *kantei-ryu* style on the signboard, and in *Edo-moji* on the curtain. The border around the curtain (55) adds a modern touch to an old form. Beside the entrance is a *kama*, the pot used for cooking rice, an unusual sight in front of a shop, though appropriate here since, in addition to beans, rice is used in Japanese sweets.

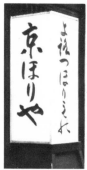
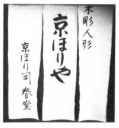

56–57. Doll shop, *Kyohoriya*, Kyoto.
The white *noren* of this shop contrasts strongly with the black latticework of the structure, and this, together with the old wooden *kamban*, conjures up an atmosphere of age. The lettering on the curtain is *kiri-moji*, created by cutting letters out of a piece of paper and then using the paper as a stencil. The chunky character of the letters makes them particularly apt for a shop selling carved wooden dolls.

58–60. Tea house, *Ichiriki*, Kyoto.
When the Japanese think of Kyoto, they sometimes remember those shades of color that are unique to the city. Among these is a combination of a particular shade of vermilion together with the dusty black favored by traditional Kyoto architecture, seen in this old and famous tea house (59). Though food is served in a tea house, it is associated rather with the exclusive and elegant pleasures of the *geisha*. Such pleasures are disappearing fast in modern Japan, and the few tea houses that still survive preserve the exquisiteness of taste of bygone ages. Apart from the color combination mentioned above, another point of admiration in this tea house is the translucent *noren* (60), whose pale quality is reminiscent of the diffused sunlight for which Kyoto is known. The Chinese characters are bold, contrasting with the delicacy of their surroundings. Age is certainly suggested, but also a beauty that transcends age.

61. Tea house, *Fumiyo*, Kyoto.
Though the *tensho* style of writing ordinarily has masculine associations, something like Gothic lettering in the West, here it is purposely softened, giving it a modern, gentler quality. The effect is one of modesty rather than strength, though the underlying balance adds a note of forthrightness that is supposed to be an integral part of the character of the Kyoto woman. The color scheme shown in the plate, white on dark brown, is for the winter; in the summer it is white on dark blue. This sensitivity to seasonal change is indicative of the attention paid to details in such establishments.

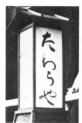
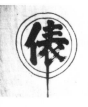

62–63. Inn, *Tawaraya*, Kyoto.
On the lantern three ways of "reading" the name are given: in *kana* on the right side, in *kanji*, and in a stylized picture of a rice bale, the meaning of *tawara*. This conceit gives a pleasantly rural atmosphere to this old and very famous inn in the middle of modern Kyoto. The lettering on the *noren* (63) is *hige-moji* and the

proportion of the letters to the area of the curtain is particularly well balanced. The *gyosho* form is used and the entire effect is one of fitting yet simple elegance.

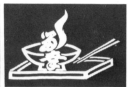

64–65. Restaurant, *Shiruko*, Kyoto.
The name refers to the hot, sweet dish that is one of the specialities of the restaurant. Another is the famous *Rikyu-bento*, a sort of set lunch named after the celebrated sixteenth-century aesthete and teamaster. On the *noren*, the bowl the sweet is served in is shown and within it is written the shop name, with the character for *shi* emerging as the rising steam. Below (65) is the same emblem as it appears on a curtain inside the restaurant.

66–72.
This series of plates shows the advertising flag used by sellers of a sweet called *kakigori* or *korimizu*, which is crushed ice with various syrups poured over it, similar to *frappé* or Persian sherbet, except that in Japan it has no patrician associations. By tradition the flag has one large character, the Chinese character for ice, written in *hige-moji*, with a background of waves and *chidori*, "plovers," which increases the impression of coolness.

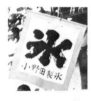

66. Tokyo.
The usual color for the *kanji* is red, but it is blue here and the traditional *hige-moji* has been modernized.

67. Kanazawa, Ishikawa Prefecture.
This is a more traditional form since the character is conservatively written and the waves are included.

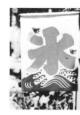

68. Hirosaki, Aomori Prefecture.
The most traditional of these examples, this flag includes all the expected elements.

69. Tokyo.
This may be slightly less traditional in feeling than the previous one because of the patterned background, but all the elements are still treated in a fairly conventional manner.

70. Tokyo.
A contemporary-looking style of *hige-moji* makes this example appear more modern.

71. Kanazawa, Ishikawa Prefecture.
The flag has the modern innovation of a red border enclosing the character.

72. Tokyo.
More traditional in treatment, this is similar to plate 69 in the overelaborateness of its *hige-moji* style.

73. Factory, *Yubahan*, Kyoto.
The first part of the name is taken from *yuba*, the dried bean curd used in certain dishes of the *kaiseki* cuisine. The latter part of the name is from *hanbun*, "half." The implication is that the shop is run by a *hanninmae*, or a "semiprofessional," who although he has not yet achieved full status is nonetheless trying his best. This humble attitude is emphasized by the letters being placed low on the curtain to give the feeling of modesty and dedicated service. The Japanese interpret all these signs without a trace of cynicism. Despite the humility of the *noren*, however, the movement of the brush in the calligraphy is impeccable.

117

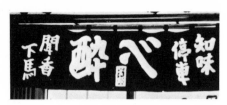

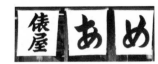

74. Restaurant, *Suishin*, Tokyo.
This establishment serves *kama-meshi*, rice steamed with various ingredients and served in the pot. There is no attempt at modesty: the name alone is repeated three times—on the electric *kamban*, on the *noren*, and on the papered doors. On the curtain the name is written in the modern manner, from left to right, but otherwise the signs follow the older style, from right to left. The mix is typically Tokyo, and its very imbalance gives a genial and informal feeling.

75–76. Restaurant, *Zuboraya*, Osaka.
The speciality of the house, as is obvious from the giant models hanging from the facade, is *fugu*, "blowfish." The idea for such a decoration perhaps came from the *fugu-chochin*, a lantern made from the skin of a blowfish inflated and lacquered. The characters are in *kantei-ryu*, but the manner is pure Osaka, with its ostentation, not to say vulgarity. One might expect low prices to accord with this absence of good taste, but *fugu* is an expensive delicacy and only accredited and highly skilled cooks can properly prepare this potentially lethal fish.

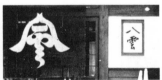

77–78. Restaurant, *Yakumo*, Nagoya.
The name, taken from Chinese mythology, means "eightfold cloud," and a freely written version of it forms the emblem on the curtain. The characters on the signboard (78) are *kiri-moji*, which have folkcraft overtones to the Japanese and thus reflect the traditional rural menu available here. There is a certain lack of balance among the characters on the *kamban*, *noren* and *chochin*, yet this, perhaps, adds to the rustic feeling of the whole.

79. Sweet shop, *Tawaraya*, Kanazawa, Ishikawa Prefecture.
Children are the best customers at a shop like this and the style of the curtain reflects this. The word *ame*, a sweet bean paste, is spelled out in very well drawn, simple *kaisho*, with each section of the curtain bearing one *kana* letter, just as each square of a child's exercise book holds a single letter.

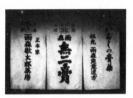

80–81. Medicine shop, *Amamori Keitaro Yakubo*, Kyoto.
The first two words are the owner's name, the last is the old word for drugstore. The *kamban* is old-fashioned and the combination of common-sense *kaisho* and *hige-moji* suggests age and probity. The curtain, though not the original one, preserves the old-world atmosphere. The name of the shop is on the left, and in the middle is a statement of the first-rate quality of the shop's ointment.

82–86. Restaurant, *Karafune*, Kyoto.
Despite the somewhat ordinary *kama-meshi* served, this is a reconstructed version of a very old restaurant, and has accumulated rather than created a style of its own. Some of the signs have no connection with the restaurant or the name, but remain to contribute to the charmingly mixed-up effect. The rustic picture of the pot on the *shoji*-style door (85) conflicts with the elegance of the old *kamban* (83 and 84). This bears two different writings of *shira-ume*, the one meaning "plum blossom" and the other "white girl," which perhaps is a play on a former famous *geisha*'s name. The name of the restaurant is indicative of its idiosyncrasies, for it is called "Chinese Boat," or, to give an approximation of the nuances present in the original, "Ship of Cathay." Since foreign things were for a long time associated with the bizarre, the name is fitting enough for this jumbled, if pleasing, exterior. The *chochin* (86), with its mixture of styles, adds a final touch to the confusion.

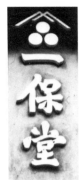

87–89. Shop selling tea, *Ippodo*, Kyoto.

This may be the most famous of all shops in Japan dealing in tea; its product is known to all connoisseurs, its name familiar to everyone. The signboard, curtain and lantern are all combinations of black and white. The house name, beautifully written in incisive black against the pure white of the *noren* (89), is particularly impressive, set off as it is by the blackness of the building itself. The character for tea is written in *gyosho*, while *Ippodo* is in *kaisho*. The design of the *kamban* (87) is a symbolic representation of tea bales under a roof, inferring that the shop has plenty of tea in store. The name itself means "one branch," and the implication is the management does not want to open any others and thus there will be none of the decline in quality that usually accompanies expansion. The customer can shop here and be confident he will receive the best tea there is.

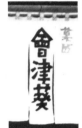

90–91. Sweet shop, *Aizu Aoi*, Aizu-Wakamatsu, Fukushima Prefecture.

The feeling of this shop is fresh and crisp. Though the *noren* is modern, it was obviously designed by a master to harmonize with the building. The curtain is traditional in length but is unusual for its *kiri-moji* lettering, which combines with the rough-woven cloth ground and the touch of vermilion to give a calculated, balanced effect.

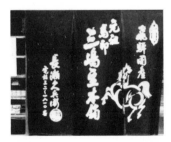

92. Shop selling beans, *Mishima Mame Hompo*, Aizu-Wakamatsu, Fukushima Prefecture.

This shop sells various sorts of tubers, dried beans and peanuts. The *kamban* is modern, but the *noren* is in traditional style. On it a horse is drawn, the entire animal being outlined with one stroke of the brush, a special technique of the area. Horses used to be common around Aizu-Wakamatsu, which may account for the motif on the curtain. An additional implication, however, is that

the service is brisk and lively, for these, together with prosperity, are the attributes of the horse.

93. Lacquer shop, *Suzukiya Rihei*, Aizu-Wakamatsu, Fukushima Prefecture.

Lacquer is a prized possession in Japan. It is also a traditional craft, and this shop selling it could scarcely be better located than in a old-style storehouse, used for keeping valuables in since it was fire- and rat-proof. Though the entrance has been reconstructed, the typical *namako-kabe* walls and the special windows on the second story are unchanged. The *Edo-moji* calligraphy on the *noren* has great assurance.

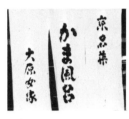

94. Sweet shop, *Oharameya*, Kyoto.

This shop sells a sweet cake called *kamaburo*, written in *gyosho* style in the center of the curtain. The cake has a rounded shape like a half-sphere, reminiscent of the heads of Japanese dolls with their elaborate hairstyles; or the roundness may be derived from the shape of the old-style oven, one of the meanings of *kama*. Whatever the origin, the curves of the cake are reflected in the calligraphy used on the curtain.

95–96. Restaurant, *Takemura*, Tokyo.

The speciality is *shiruko*, the hot, sweet dish made of beans that is often eaten as a snack. On the *noren* the rim of the serving bowl is incorporated into the design, with *shiruko* written in *gyosho* inside it. The position of the lantern (95), though not often seen now, was once common, and the lantern itself bears the name of the shop in exceptionally well drawn *gyosho* that conveys a gentleness suited to the mainly female clientele.

97–98. Restaurant, *Sasanoyuki*, Tokyo.

The various forms of *tofu*, "bean curd," are served here, and the restaurant's name has evolved from a story about the original Edo owner who took some of his pure white bean curd to a famous temple. There it was praised by the abbot, who said that it was as white as the snow (*yuki*) on bamboo grass (*sasa*). As a reflection of the name, the *noren* bears the outline of a snowflake, the calligraphy being *kaisho* style against a whiteness that recalls the color of the bean curd served.

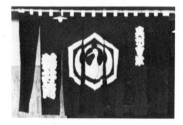

99. Restaurant, *Tsuru Izutsu*, Aizu-Wakamatsu, Fukushima Prefecture.

Tsuru is the Japanese word for "crane," hence the emblem with a crane motif in the middle of the curtain between the two lines of *Edo-moji*. The two poles that flank the entrance are a country-style touch and the banners hanging from them invite people in to rest awhile. The style of this building intimates that it was once an inn on one of the main routes in Japan, where lords and their retinues could break their journey.

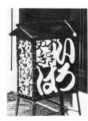

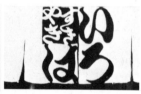

100–102. Restaurant, *Iroha*, Kyoto.

Served here is *sukiyaki*, a meat dish that has maintained and even increased its popularity. The modern look of the *kiri-moji* stencil technique is appropriate, and here both the positive and the negative of it are used. Particularly successful is the lantern: unlit, the effect is light on dark; lit, the opposite effect becomes stronger. The two *noren* support the popular elegance that the establishment aims for. The inner curtain (100) is made of rope, a now-rare treatment that contrasts strongly with the modern *kamban* (101), unusual in its own right because it is made of metal.

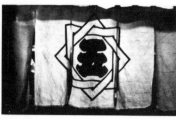

103–104. Restaurant, *Goemon*, Tokyo.

This is another restaurant where history is insisted upon. The curtain bears an Edo-style emblem, which is then repeated on the storehouse wall (104). On the lantern one of the specialities, *yudofu*, is written in the script of that period. The effect, however, is a little too perfect. There is something of a Williamsburg feeling about it all, despite or because of the impeccable historical reconstruction.

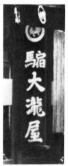

105. Restaurant, *Otakiya*, Fukushima Prefecture.

This building was an old country inn that has been converted into a restaurant. The curtain and the *kamban* both proclaim it as a "horse" inn, where traveling daimyo could rest or change their horses. The entrance to the stables can be seen to the left with the red emblem on the doors. The buckets in front were placed above a barrel of water in case of fire.

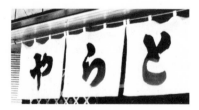

106. Sweet shop, *Toraya*, Tokyo.

This shop sells the sweet jelly bean candy called *yokan*. Its curtain somehow gives the Japanese a "sweet" feeling —slightly juvenile but with a good adult balance of black and white. This balance is reflected in the entire effect of the store front, a successful combination of old and new.

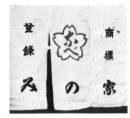
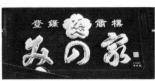

107–108. Restaurant, *Minoya*, Tokyo.

Here you can eat *sakura-niku*, a widely used euphemism for horsemeat. This meat is supposed to be pinker that that of other animals, hence its name, for *sakura* means "cherry blossom." The blossom shape appears on the *noren* with the word *nabe* ("pot") written inside the blossom in *gyosho* style to indicate *sukiyaki* that is the commonest dish. The *kamban* (108) is very grand, with gilt letters on a black background. In general, horsemeat has unfavorable associations in Japan, but despite this there are some dedicated enthusiasts.

109. Restaurant, *Kakusho*, Hida-Takayama, Gifu Prefecture.

This exclusive restaurant specializes in *shojin* cooking, a traditional Buddhist cuisine that is vegetarian. One does not enter here lightly: reservations and even introductions are necessary. All this is plain enough to those skilled enough to read it, for the facade is unostentatious to an almost ostentatious degree. In the transcription of the name an unusual device has been used: around the character *sho*, a square has been drawn. This is the meaning of *kaku*, and thus this part of the name is pictorialized rather than written. The calligraphy, however, is painstakingly "poor."

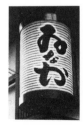

110–112. Restaurant, *Inaka*, Tokyo.

As suggested by the name, which means "country," regional dishes are served here. The interest of the photos lies not so much in the beauty of the calligraphy as in the variety of lanterns and treatment of the name. The variations give an overall lively feeling, an ambience connected with the Tokyo of former days.

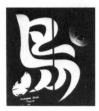

113. Restaurant, *Tori*, Tokyo.

The name means "bird," and on the sign the character has been rendered to resemble a bird. A touch that is typical of modern Tokyo is the English at the bottom.

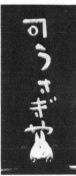
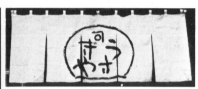

114. Sweet shop, *Usagiya*, Tokyo.

Here the use of the style of letters reserved for writing *haiku* poems gives the store a pleasant aspect of innocence, even naivety, an effect that is enhanced by the large amount of white space employed. Though the name may have been the original owner's, it also means "rabbit," an animal beloved by children. A lifelike replica rests at the bottom of the *kamban*.

115. Sweet shop, *Sasama*, Tokyo.

Kaisho is written with a serene, feminine touch on the *noren* to suit the customers, who are women rather than men. The black letters on the white cloth create an impression of cleanliness.

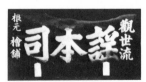

116. Bookstore, *Utaibon Tsukasa*, Kyoto.

This highly specialized store sells only Noh drama scripts of the Kanze school. Fittingly, the facade shows dignity: the imposing window is in the shape of a plum

blossom and the majestic old *kamban* of untrimmed wood is supported on blocks painted white, a sensitive design touch.

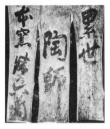

117. Ceramic workshop, *Kurose*, Kyoto.
This is both the home of the artist and his shop. The curtain is old, dirty, and resembles leather rather than cloth, indicating more concern for the craft itself than for the sale of the products. The atmosphere is of an old and esteemed house that takes pride in the quality of its wares.

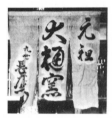

118. Ceramic workshop, *Ohigama*, Kanazawa, Ishikawa Prefecture.
As in the workshop above, the emphasis is on art and the fact that pottery is made on the premises. This is judged so important that the impression of a tidy shop is completely sacrificed. The characters are beautifully drawn in the *gyosho* style on the old *noren*, which is torn and has been allowed to remain that way.

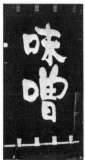 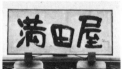

119–121. Shop selling *miso*, *Mitsutaya*, Aizu-Wakamatsu, Fukushima Prefecture.
Miso is the fermented bean paste that is the basis for much Japanese cuisine, and this is the main store of a manufacturer. The signboard (120) is brand new, with letters in *gendai-moji*, while the two curtains are written by the owner with folk-style lettering. The first (119)

reads *miso*, and the next (121) *tempo*, the name of the *miso* made here. The straps attaching the *hiyoke-noren* to the bamboo poles are white, a graceful touch of design.

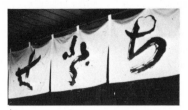

122. Sweet shop, *Chitose*, Tokyo.
The simplicity of the facade and the squares framing the *gyosho* letters appeal to the children this store caters to.

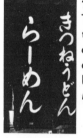

123. Noodle stall, Tokyo.
These eating stalls on wheels appear in the late evening to serve people on their way home after a night out on the town. Though the stalls are definitely lower class by association, the *kaisho* style lettering on the hanging curtains is very well drawn. The curtains read *ramen* and *kitsune-udon*, two kinds of noodles served.

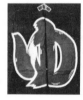

124–125. Bathhouses, Kyoto.
These are two *noren*, one old and the other new. The letter on them is *yu*, "hot water." The old-style curtain is red, with simplified *hige-moji*, and it has a satisfyingly traditional feeling. The second, given by a soap company to the bathhouses as a form of advertising, is less successful. The character is not so skillfully done and the sponsor has worked in a soap suds design.

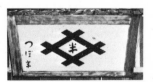

126. Restaurant, *Tsubohan*, Tokyo.
This establishment mainly serves *ochazuke*, rice with tea poured over it, a light meal that is filling without being satiating. On the lantern the location of this branch is stated as Ginza 5-chome. On the *kamban* a traditional crest is used together with *han*, an abbreviation of the restaurant name.

127–141.

This series of plates illustrates variations of the symbols placed on gables and walls of houses and *kura* ("storehouses") as invocations against fire. This was a common enough occurrence where many of the houses were thatched with sedge (127, 134). The most usual symbol was the character for *mizu*, "water" (127–128, 130–141), or sometimes the *kana* syllable *mi* standing for it (129). Symbols associated with water are also seen, such as the characters for dragon, a creature believed to live in water, and for cloud (131). In plate 136 are seen characters for water, dragon, cloud, *zui* (a Buddhist word for water) and, in addition, *fuku*, representing happiness, which by extension comes to mean freedom from disaster. In plate 138 the water character is combined with pictures of a turtle (a water creature) and stars, which are associated with clouds and the elements. In these propitiatory signs, the style of writing is less important than in the signs used as advertisements in the first section of the book, and preference is given to a highly visible style. In plates 128 and 134, the Chinese character is in a free *sosho* style. In plate 141 it has the square *kaku-moji* form. All of this series consists of the roofs of houses except plate 140, which shows the use of the symbol on a storehouse.

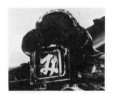

127. Samegai, Shiga Prefecture.

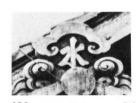

128. Samegai, Shiga Prefecture.

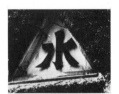

129. Shimoda, Shizuoka Prefecture.

130. Hida-Takayama, Gifu Prefecture.

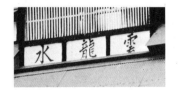

131. Kitagami, Iwate Prefecture.

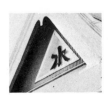

132. Samegai, Shiga Prefecture.

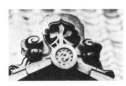

133. Hida-Takayama, Gifu Prefecture.

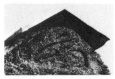

134. Chichibu, Saitama Prefecture.

135. Omi, Shiga Prefecture.

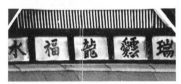

136. Kitagami, Iwate Prefecture.

137. Azusagawamura, Nagano Prefecture.

138. Tsuchiura, Ibaraki Prefecture.

139. Hida-Takayama, Gifu Prefecture.

140. Azusagawamura, Nagano Prefecture.

141. Samegai, Shiga Prefecture.

142–144. Hakuba, Nagano Prefecture.
Most of the gables of the houses in this small hamlet bear the character *kotobuki*. The word means "felicitations" and represents thanks-in-advance to the gods of the elements for preventing misfortune. The characters are written in *sosho* (142, 143) and *gyosho* (144). Another distinctive feature of this village is the roofs, which are mostly double- or triple-tiered.

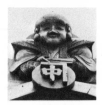

145. Samegai, Shiga Prefecture.

This shows the happy face of Ebisu, one of seven folkloric gods of good fortune. Traditionally he is associated with the sea, with fish, and for some reason with sake. His presence is appropriate here as this was formerly a sake shop. Beneath him is the right-angled symbol that indicates the shop was licensed by the Tokugawa government. Next to this is the character *naka*, perhaps an abbreviation of the former owner's family name, since such names as Tanaka and Yamanaka are common in Japan.

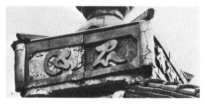

146–147. Samegai, Shiga Prefecture.

These two views are of a temple roof. The one (146) has a globe, representing the Buddhist universe, and some Sanskrit letters, and the other (147) the character for *inochi*, "life," near the well-known Buddhist swastika, called *manji* in Japanese.

148. Hida-Takayama, Gifu Prefecture.
Under the slate model of a dove, the letters *ka* and *na* can be seen, which might indicate some common family name like Kanayama or Kanazawa. Below it on the tile end is the auspicious pattern called *tomoe*.

149. Matsumoto, Nagano Prefecture.
The highly ornate decorations seen in a typical example here denote a family of considerable wealth. The character *ue* is placed in a circle, representing some family name such as Ueda or Uematsu.

150. Itsukaichi, Tokyo.
The family mark seen on two of the tile ends consists of a pictorial symbol and a Chinese character. The former is the stylized representation of two mountains, *yama* in Japanese, and the latter is *ta*, also pronounced *da*. Thus the reading would be Yamada, a well-known family name.

151–153. Okuchichibu, Saitama Prefecture.
The photos are all of walls of storehouses with the character *naka* on them. This makes one presume that they all belonged to branches of the same family, even though they are not in the same village. The circle in one of them and the triangle in another indicate that they belonged to different sons of the same family. It is characteristic that these symbols are simple and roughly executed, while the form of the characters is strikingly handsome.

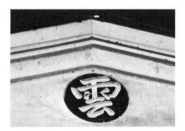

154–155. Matsumoto, Nagano Prefecture.
These are two views of the same storehouse, one wall bearing the character for dragon and the other for cloud. Both are symbols of sympathetic magic against fire.

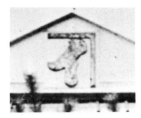

156. Okuchichibu, Saitama Prefecture.
The *katakana* syllable *i* may have represented a family name such as Ikeda or Iida. The right-angled line indicates that the family had a business license from the Tokugawa government.

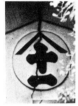

157. Okuchichibu, Saitama Prefecture.
The *yago*, or "plaque," on this storehouse has the characters for "eleven" placed under a small mountain (*yama*). In reconstructing a possible reading, if only the first syllable of *yama* is used together with the old-fashioned alternate reading for the numbers, it would read *ya-to-i*. This would be Yatoi, a common name.

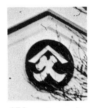

158. Ouchi, Fukushima Prefecture.
Again a pictorial representation is used for *yama*, "mountain." Under it is the character *kyu*. The resulting combination may be read a number of ways, two of which are the names Hisanaga and Kubo.

159–160. Nara.
These two *yago* from the same storehouse both show the *kaku-moji* style. The character is that for tree, *ki*, and so the family name can be one of many possibilities: Kimura, Kihara and so on. Though made of the commonest materials, those of the wall itself, these plaques were well designed and carefully wrought.

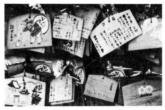

161. Kiyomizu-dera, Kyoto.
This is a typically jumbled collection of votive *ema*. Three show the god Ebisu with his "bag of happiness," and they probably have a specific wish written on the reverse side. The two mice mean that the donor was born in the Year of the Rat, and in all likelihood he also has inscribed his wish on the back. At the bottom right, a plaque bears the request, "Please cure my brother's illness." Another with cherry blossoms painted on it in the second from bottom row has inscribed, "Please let this bride have a male child," presumably written by the groom's mother.

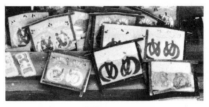

162. Kawagoe, Saitama Prefecture.
This temple has become famous for its beneficial influence on people with bad eyes. Thus a number of plaques have one letter repeated in mirror image, creating an effect like a pair of eyes. The letter is *me*, the pronunciation being the same as the Chinese character for "eye."

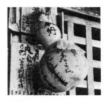

163. Tenno-ji, Sendai, Miyagi Prefecture.
In former times it was customary for pilgrims and other travelers to carry water with them in gourds, and one way of showing reverence for the gods was to offer water to their statues. Thus the gourd presented here as a votive gift has many appropriate associations. On its side the donor has written the invocation, "May God be with me."

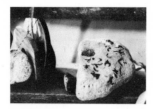

164. Io-ji, Sendai, Miyagi Prefecture.
This temple is a favorite place of pilgrimage for the sick. Votive objects may be the usual wooden boards, or they may be anything on which the prayer can be written. On this oddly shaped rock is the simple and touching statement, "Dear Deity, I cannot walk."

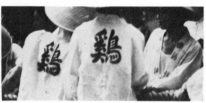

165–167. Kyoto.
In this famous annual Gion Festival, the young Kyoto men wear an attractive assortment of costumes. The letter on the back of the costume in plate 166 is in *gyosho* style and reads *niwatori*, meaning "chicken" but referring to the district this particular team comes from. The character in plate 167 is in *kaisho* style and reads *naga*, standing for another place-name. Plate 165 has *tensho* lettering, reading *do* for yet another district. Kyoto festivals have all the elegance accruing from the court aristocracy that resided there for so long, in contrast with the Tokyo festivals that have the boldness of the samurai caste.

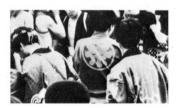

168. Tokyo.
During the annual Kanda Festival, men carrying the large shrine seen in the background wear the traditional short coats called *hanten*. The character on the back of these reads *matsuri*, "festival," and the design is a strong, red *Edo-moji* style against a blue background, a combination that is virile, active, and rough.

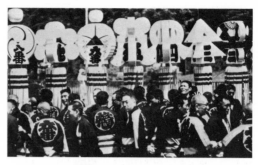

169. Tokyo.
This is the *Dezomeshiki*, or the Firemen's Festival. The *hanten* coats worn by the firemen on the occasion bear the district of the brigade and the fireman's ranking in the team. The coat of the man in the middle reads *tsutsusaki*, meaning "leading hoseman," a high-ranking and dangerous position. The man on the left bears the marking *rokuban*, which means he is sixth in the hose team. The decorated poles in the background are called *matoi*. Originally they were used as fire-fighting tools, for, in addition to using water to put out fires, the Edo firemen would demolish the burning building so that the fire would not spread. Thus the *matoi* were used for pushing down walls and battering in roofs. They were white so they could be seen at night, and the bands around their necks were an identification of where the brigade came from. The number of bands matches the number of stripes on the white area of the firemen's uniform.

170. Tokyo.
There are even miniature versions of the traditional costumes for children to wear at festivals. This child is dressed in a *hanten* on which *samban* ("third rank") is written.

171. Tokyo.
This fireman's coat bears the inscription *Fuku-kumi-gashira*, which might be translated as "Vice President of the Association."

172–179.

The next series is of lanterns at temples, shrines, or festivals. They are all of the type known as *Gifu-chochin*, because they originated in Gifu Prefecture. Their characteristic is that the bamboo supports of the paper are placed regularly in a column shape, in contrast with other crossing designs such as the one seen in plate 16.

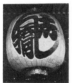

172. Tokyo.
This huge lantern bears the inscription *akahashi*, "red bridge," written in *hige-moji* style.

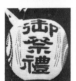

173. Tokyo.
The *reisho* style of characters is used for the word *gosairei*, a word for "festival" used on lanterns in shrines and temples and at *matsuri*.

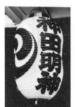

174. Tokyo.
Here the name of the god of the shrine, Kanda Myojin, is written in *kaisho*.

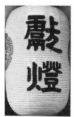

175. Kyoto.
The word *kento*, in *reisho* style, refers to the practice of donating candles to temples and shrines.

176. Kyoto.
The same word is written in a different, more fluid fashion.

177. Kyoto.
Gosairei, the same word as in plate 173, is written on this lantern but with the more genteel *tensho* style of the cultural capital.

178. Tokyo.
This is the lantern of the Daikoku-ten Temple in Meguro district. *Kaiundaikoku-ten*, roughly translated as "Great Luck," is written in *hige-moji*.

179. Tokyo.
Well-known to tourists, this large and handsome lantern hangs in the gate at the entrance to the Asakusa Kannon Temple. The traditional *Edo-moji* read *Kofune-cho*, the name of the district.

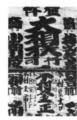

180. Nara.
This is an ancient board of *sumo*, Japanese wrestling, and it probably dates back to the eighteenth century. The characters give the name and rank of the contenders and the writing style is that traditionally associated with the sport.

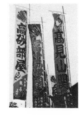

181. Nagoya.
These banners, adorned with the names of well-known *sumo* wrestlers, are flown near the stadium where the contest is held. They are donated by sponsors, whose names are also written on the flags.

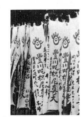

182. Toyokawa, Aichi Prefecture.
These banners decorate the path to a Shinto shrine. The symbol that decorates them is the *nyoi-hoju*, the burning jewel held by the Buddha himself. Each of the flags was donated by one of the small businesses in the area.

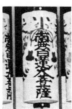

183. Nagoya.
This Nichiren Buddhist temple displays an unusually colorful set of lanterns at its festival. The usual colors for lanterns are black and red, with occasional yellow and green. Thus the orange, brown, green and blue here are rare, especially at a temple. The Buddhist prayer on the lanterns, in *reisho* style, is *Namu Nichiren Daibosatsu*.

CHART OF SCRIPTS

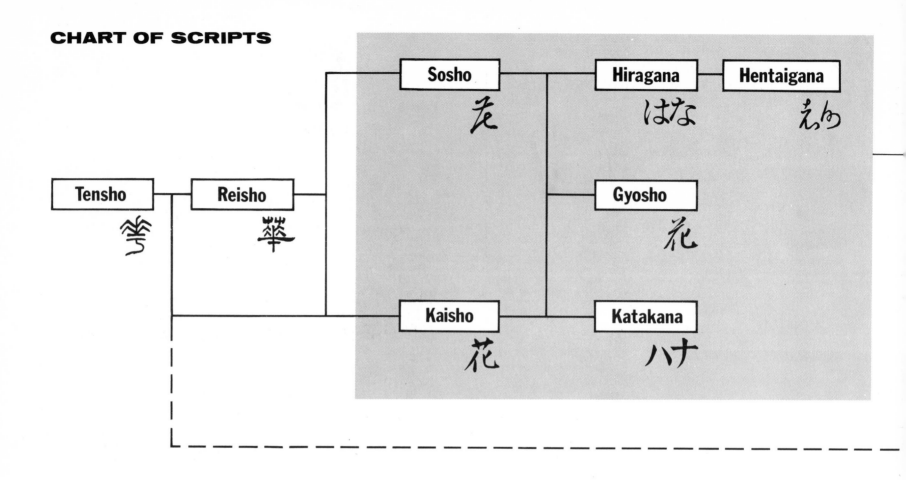

On the left-hand page are the traditional scripts used for official and unofficial purposes. On the right are the Edo period (seventeenth–nineteenth century) scripts with specialized uses, such as advertising and the theater. In addition to the scripts shown above there are modern varieties of writing called *gendai-moji*. The Chinese character selected to show the different scripts is *hana*, "flower."

Tensho ——————— This, an early Chinese script evolved around the third century B. C., was used for official purposes. As it was difficult to write, it gave rise to the easier forms of *reisho* and *kaisho*.

Reisho ——————— A script from China, first used for informal, then formal matters.

Kaisho —————— Also originally an informal script that was adopted for formal uses in China, it is sober in character and symmetrically regular, as compared to *sosho*.

Sosho ——————— A direct descendant and an abbreviated form of *reisho*, it is a fluid, cursive script employed in letter-writing and for other informal occasions.

Gyosho ——————— A mixture of *reisho* and *kaisho* that is both easier to read and write and yet is artistic and fairly relaxed.

Hiragana ——————— A purely Japanese development of the Heian period (eighth–twelfth centuries), this abbreviated *sosho* style forms one of the Japanese syllabaries. Its rounded, gentle forms have feminine connotations, and it was used for writing *waka* poetry.

Hentaigana —————— This style, which is a combination of *hiragana* and *sosho*, was developed in the Heian period.

Katakana —————— Used for the other syllabary of the Heian period, this style is an abbreviated form evolved from the symmetrical *kaisho*.

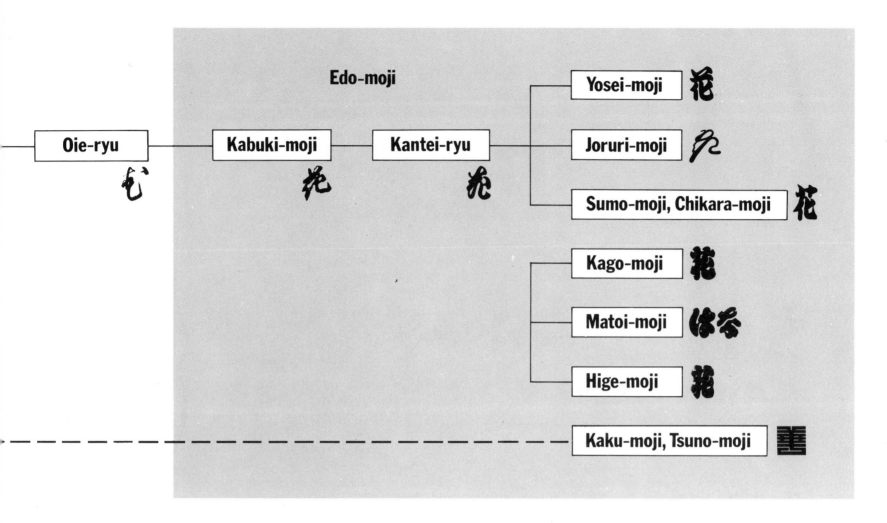

Oie-ryu ——————— A mixture, rather than a descendant, of all the different styles, developed late in the Edo period.

Kabuki-moji —————— Based on *oie-ryu*, this script was created for the *kabuki* theater. Attractive and decorative, it was used for the programs distributed to the audience.

Kantei-ryu —————— An even more design-conscious script than the *kabuki-moji*, this was also used for the *kabuki* theater.

Yosei-moji —————— At the end of the Edo and beginning of the Meiji period, *kabuki* and the other arts began to be patronized by the lower classes. *Yosei-moji* was designed to appeal to their tastes and it was a style based on *kabuki-moji*.

Joruri-moji —————— This script is a more fluid form of *yosei-moji*, created for *joruri*, the popular entertainment of ballads sung with the *shamisen*.

Sumo-moji, —————— Reflecting the strength involved in *sumo* wrestling,
Chikara-moji this bold script is notable for the lack of space between the letters and the lines.

Kago-moji —————— All the above scripts were based on handwriting, but *kago-moji* was created with printing in mind. It combines the readability of *reisho* and *kaisho* with some decorative aspects of *kantei-ryu*.

Matoi-moji —————— A slightly stronger variant of *kago-moji* used on the *matoi*, the poles carried by firemen.

Hige-moji —————— A variation of *kago-moji*, this has an additional decorative requirement that the strokes should have seven, five and three bristle traces, an auspicious combination of numbers.

Kaku-moji, —————— This variation of *tensho* adopted a design in which hor-
Tsuno-moji izontal and vertical strokes have the same thickness.

129

Afterword

People read their environments differently. On my first visit to the United States I remember how surprised I was to see the flag flying, apparently, wherever I went. My American friends did not appear even to notice this ubiquitous emblem, but to me it was everywhere I looked. It made me uneasy. I read it as an expression of extreme nationalism, a shrill call to patriotism. I remember pondering about it. How strange, I thought, to encounter in a country where individuality is so important this sudden collective emphasis.

It took me several further trips to realize that I was misreading the role of this particular emblem. I began to understand when I noticed that the Americans never appeared to "see" this flag of theirs. We Japanese, on the contrary, always see our flag because we display it only on national holidays. Otherwise it is folded up and put away. If the Americans were not seeing the emblem, then it was obviously not speaking to them—not at any rate in the manner it was to me.

I had been doing two things wrong and had hence misread the environment. For one thing, since I could not read English all that easily, I was disregarding the many advertisements that decorate American streets. Instead, I was reading symbolically, and the flag was the only symbol I could recognize. I was also, being used to a Japanese environment, reading the symbol as a kind of advertisement, as a public pronouncement of—in this case—a patriotic attitude.

As this book has indicated, the Japanese environment is filled with

advertisements, with symbols denoting this or that specific, with indications of attitude, i.e., let not fire strike this house, etc. The manner is absolutely forthright. It is aggressive and assertive to a degree. In this sense Japan is the home of the hard-sell.

At the same time these names, symbols, emblems which so fill our environment have another function. They plainly label. They are indications as practical as street signs.

In this sense Japan is perhaps little different from other countries, though the quality and quantity of signs in this country never fails to elicit foreign response. Confronted with a plethora, the visitor, unable to read a single sign, regards them as an aesthetic spectacle, as graphic art.

He is, I would maintain, correct in doing so. This also is a valid way of reading the environment. The Japanese, walking this visual jungle, is usually, on the other hand, content to extract only the ostensible meaning, i.e., that *sukiyaki* is sold here and sake is to be had there. Yet he also is moved by the underlying aesthetics. The stylistic variety of the lettering is almost infinite, yet each carries with it a series of overtones. This sign is elegant, simple, and reflects the interior design and the style of service. That sign would be bold, something traditional, something in the old Edo manner. He knows what to expect once inside.

At the same time, these shop signs, these symbols and indications, can be appreciated in their own right, as works of art—and this is how I have tried to present them in this book. While I am no specialist in either calligraphy or communications, as a designer I am moved by their beauty. I dare say a historian or a calligrapher or a communications expert would have something quite different to present. For me, however, what I see and what I wanted to show was the beauty of the shop sign, the curtain, the lantern, and all the other forms. It is the beauty of a tradition, which maintains even now.

In this light, I could, and probably should, have seen the American flag as an elegant, bright, asymmetrical composition, aesthetically typical of the country it represented. This is, at any rate, the spirit in which I want to present this aspect of my own country.

In conclusion, I would like to say what a delight and honor it has been to work with such a talented photographer as my friend, Mr. Kiyokatsu Matsumoto. Whatever this book achieves will be in great part due both to his photographs and to his many creative suggestions. I would also like to take this opportunity to thank Mr. Donald Richie, Mr. Saburo Nobuki and the staff of Kodansha International, and Mr. David Lawton, all of whom have given me invaluable guidance and encouragement. And, lastly, to the many more friends who have helped me—it would be impossible to name them all—I would like to express my deep appreciation and gratitude.

MANA MAEDA

131

Design and layout by Mana Maeda Design Association